An Illustrated Brief History of
CHINA

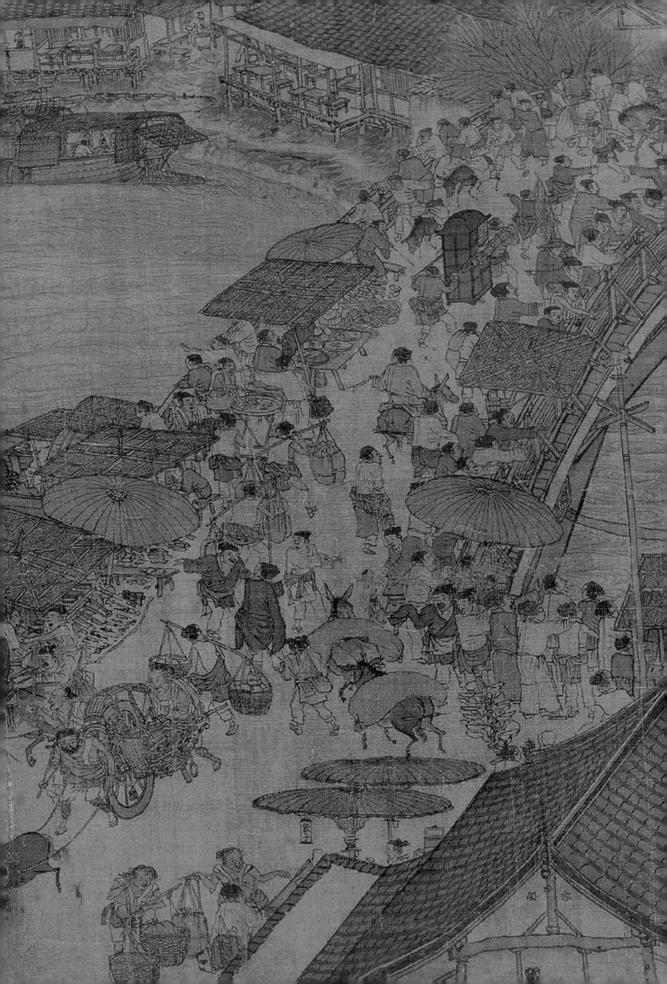

An Illustrated Brief History of
CHINA
Culture · Religion · Art · Invention

By Wang Jian and Fang Xiaoyan
Translated by Wu Yanting

Better Link Press

On page 1

A Musical Instrument Made of Bronze

Please refer to page 31.

On pages 2 and 3

The Middle Section of *Scenes along the River during the Qingming Festival*

This section dispicts the busy harbor of the Bian River. This river was a hub for water transport of grain to the capital in the Northern Song Dynasty (960–1127). It was also an important trade troute. Visible in the painting are crowds of people and cargo boats. Some people were taking a rest in a teahouse; others were having a meal. Coming and going in the river were boats that were tightly lined up. This was the well-known Hongqiao Harbor, where the transportation by land route and by water route merged.

On facing page

Playing Polo

Please refer to page 63.

Copyright © 2017 Shanghai Press & Publishing Development Company, Ltd.

All rights reserved. Unauthorized reproduction, in any manner, is prohibited.

This book is edited and designed by the Editorial Committee of *Cultural China* series

Text: Wang Jian, Fang Xiaoyan
Photographs: Cultural Relics Press, Zhai Dongfeng, Quanjing, Getty Images, ImagineChina
Translator: Wu Yanting
Interior Design: Li Jing, Hu Bin (Yuan Yinchang Design Studio)
Cover Design: Wang Wei

Editors: Yang Xiaohe, Wu Yuezhou
Editorial Director: Zhang Yicong

Senior Consultants: Sun Yong, Wu Ying, Yang Xinci
Managing Director and Publisher: Wang Youbu

ISBN: 978-1-60220-156-9

Address any comments about *An Illustrated Brief History of China* to:

Better Link Press
99 Park Ave
New York, NY 10016
USA

or

Shanghai Press and Publishing Development Company, Ltd.
F 7 Donghu Road, Shanghai, China (200031)
Email: comments_betterlinkpress@hotmail.com

Printed in China by Shenzhen Donnelley Printing Co. Ltd.

1 3 5 7 9 10 8 6 4 2

CONTENTS

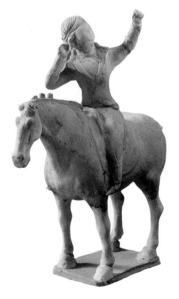

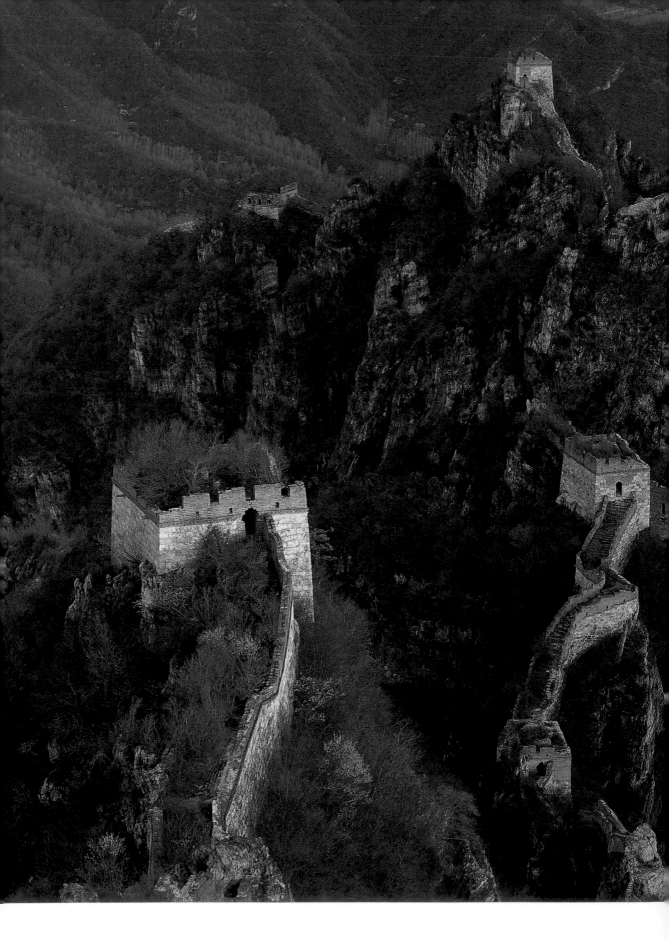

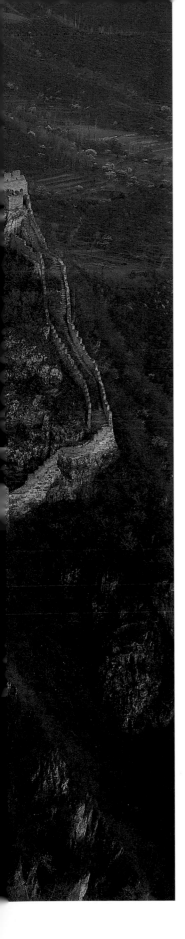

INTRODUCTION

China has a brilliant and long history—it is one of the birthplaces of human civilization. In a span of several thousand years, China has maintained its cohesion and continuity in culture. This nation in the East, with an uninterrupted history from the Xia (c. 2100–c. 1600 BC), Shang (1600–1046 BC) and Zhou (1046–256 BC) dynasties onward, along with its unique ethos, has attracted increasing attention from people all over the world. With this book in hand, you will catch a glimpse of the quintessence of Chinese culture in the expanse of five thousand years.

A voluminous book is not the only way to tell history. This book aims to pick up, from the enormous content of magnificent Chinese history, the most brilliant and significant segments to reflect the uniqueness of its culture in each historical period. Pictures of actual objects epitomizing the characteristics of the period are used to illustrate the evolution of Chinese civilization.

This book is divided into nineteen sections. It starts with Chinese ancestors in prehistoric society and goes on to outline the ancient Chinese civilization in the chronological order of Chinese dynasties, with a highlight placed on the achievements of culture, religion, art and invention of each dynasty. The theme in each section reflects outstanding material and spiritual accomplishments of that period and

◀ **The Great Wall**

The most recognizable symbol of China, the Great Wall, with its long and vivid history, consists of numerous walls and fortifications. Originally built in the third century BC as a means of preventing incursions from barbarian nomads into the Chinese Empire, the wall is one of the most extensive construction projects ever completed. The best-known and best-preserved section of the Great Wall was built in the fourteenth through seventeenth centuries, during the Ming Dynasty (1368–1644). In 1987, UNESCO designated the Great Wall a World Heritage site.

sketches out the historical developments of Chinese culture. A brief introduction placed at the beginning of each section offers a historical background and synopsis, which highlights each section.

As ancient Chinese people often say, you read history "with literature on the right hand and maps on the left." Pictures often help to present historic details in a multidimensional manner. When addressing the theme of each section, we chose to use pictures which reveal vivid details of Chinese culture. We made an effort to select pictures that are the most illustrative of the Chinese civilization at the time. These pictures are not only of archeological items but also photos, paintings, as well as charts and maps. They reveal different dimensions of Chinese civilization. The captions are simple but informative. Included at the front of the book is a pictorial chart of Chinese chronology that will make it easy for you to check references and thus better understand the progression of Chinese history.

Confucian once lamented that the passage of time is like running water that will never return. However, history will always be vibrant. Only when we begin to understand different nations and the history of different cultures can we understand why things are what they are today. If you like Chinese culture and hope to gain some understanding of it, this book will help you achieve your goal.

▶ **Temple of Confucius**
In Qufu, Shandong Province, hometown of Confucius (551–479 BC), places in connection with Confucius are still well kept. They include Confucius residence, temples in commemoration of Confucius and tombs where Confucius and his descendants were buried. This is the main building inside the Temple of Confucian, where rites of worshipping Confucius are carried out. It was built in 1724 inspired by the design of a royal palace.

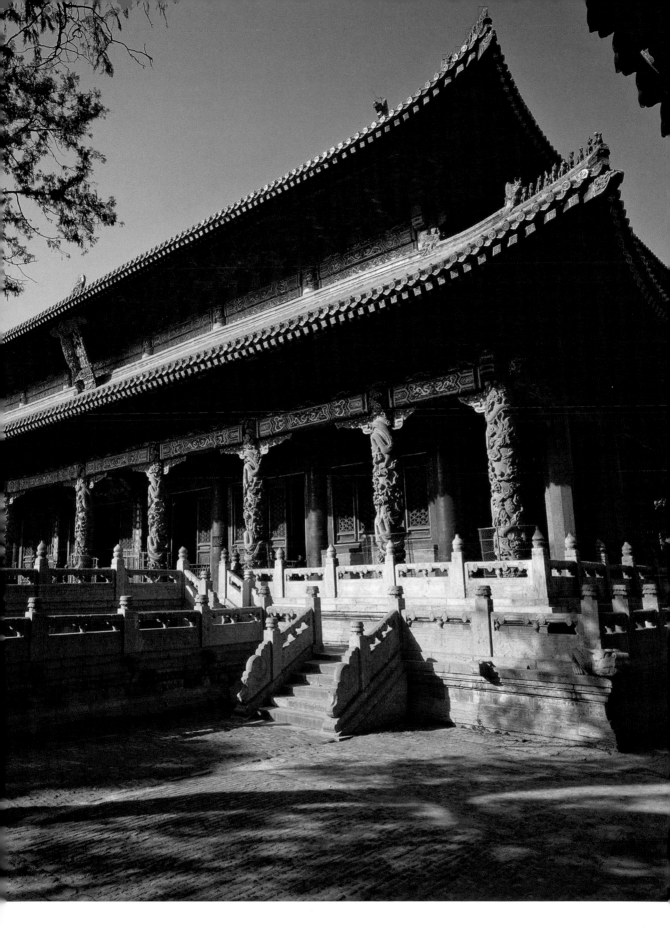

HIGHLIGHTS IN HISTORY

1 million years ago	4,300 BC	2,500 BC

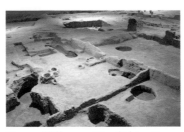

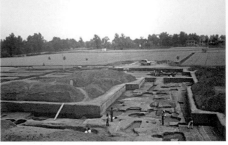

Early human fossils in the Paleolithic era that date back to 460,000 to 230,000 years ago were found in Mountain Longgu, Zhoukoudian, Beijing.

Banpo Village, a Neolithic site of human settlement that dates back to around 5,000 BC, was found in Banpo Village of Xi'an, Shaanxi Province.

Silk fabric was found dating from the Dawenkou Culture period, 4,300 BC.

In Erlitou, Yanshi, Henan Province, two sites of palatial complex were found, dating from 2,100 BC to 1,700 BC. These palaces, featuring central axis, were similar to those of the Xia Dynasty. They are the earliest palatial buildings ever known in China and became a prototype for many Chinese palatial structures to follow.

Cultural relics in the earliest Paleolithic period of Europe were found in the Grotto of Vallonnet near Menton in France. They date back to 950,000 to 900,000 years ago.

In 4,300 BC, village settlements appeared in Sumer in Mesopotamia, West Asia. These settlements grew into townships based around temple structures, thus laying the foundation of urban civilization.

Giza is the oldest and largest of the three pyramids in the Giza pyramid complex bordering what is now El Giza, Egypt. It was built between 2589 BC and 2566 BC in honor of the Egyptian Pharaoh Khufu.

300 BC	200 BC	100 BC

In 278 BC, the Chinese poet Qu Yuan, well-known for his *Li Sao* and *Jiu Ge*, committed suicide by throwing himself into the river. The traditional Chinese festival, the Dragon Boat Festival, is said to have originated in memory of the poet's death.

Around the second century BC, *Zhoubi Suanjing* in Chinese was completed. This book cites Pythagorean Law, making it the earliest record ever found in Chinese documents.

Chinese explorer Zhang Qian (?–114 BC) was dispatched twice as envoy to establish relations with countries in Central Asia, which made possible the development of the Silk Road.

The writing of the *Mahabharata*, an Indian epic poem in Sanskrit, began around 350 BC.

The Lighthouse of Alexandria, a.k.a. The Pharos of Alexandria, was built around 280 BC. It is one of the Seven Wonders of the Ancient World.

In 59 BC Acta Diurna, the earliest prototype of a newspaper, was used as a bulletin board to announce the daily proceedings and agendas of the Roman Senate.

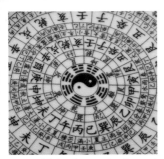

China began its formal historical record-keeping in 841 BC.

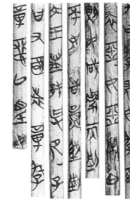

Laozi (571–471 BC), founder of the Chinese Daoism, philosopher and thinker, is known for his philosophical masterpiece, *Daode Jing* (*Classic of the Way and Its Virtue*).

Buddhism was founded by Shakyamuni in sixth century BC in India.

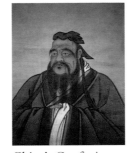

China's Confucius school of thoughts began with Confucius (551–479 BC) and became the centerpiece of traditional Chinese culture in the subsequent 2,000-plus years of Chinese history.

In 469 BC, Socrates was born.

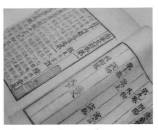

Zhuangzi (around 369–286 BC) was one of the principal founders of Daoism. His philosophy and that of Laozi (founder of Daoism) are combined as the "philosophy of Lao-Zhuang," but Zhuangzi's writing is deemed more brilliant. He is known for his work *Zhuangzi*.

In 384 BC, Aristotle was born. Around 387 BC, Plato began to tutor at the Academy in Athens, where he formed the school of Plato philosophy.

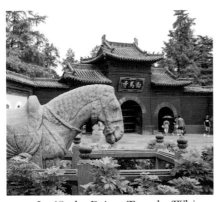

In 68, the Baima Temple (White Horse Temple) was built in Luoyang in Henan Province, making it the earliest Buddhist Temple in a Han-Chinese setting.

The earliest Maya hieroglyphic script was dated around 1 AD in Mesoamerica.

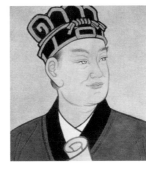

In 105, Cai Lun (c. 63–121) invented a type of paper that was made from the bark of trees, remnants of hemp, rags of cloth, and fishing nets. The method later gained nationwide recognition. This type of paper is called "the paper of Marquis Cai."

The Colosseum of Rome was built around 70–80.

Trajan's Column in Rome was built in 113.

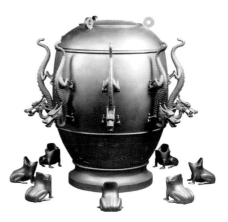

In 132, Zhang Heng (78–139) invented the world's first seismometer named Earthquake Weathervane, which later successfully forecasted an earthquake taking place in west Gansu Province.

The oldest Sanskrit inscription was found in India around 150.

HIGHLIGHTS IN HISTORY

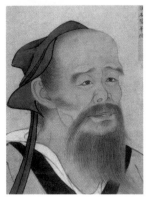

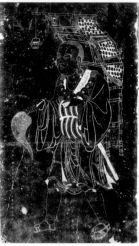

Ancient Chinese physician Hua Tuo (c. 145–208) was a master of internal medicine, gynaecology and paediatric cases and acupuncture. He used *mafeisan*, an anaesthetics which he invented for general anaesthesia during abdomen surgery.

The oldest Maya stelae were built around 164.

In 627, Tang Dynasty (618–907) Buddhist monk Xuanzang (602–664) departed Chang'an (today's Xi'an) and began his journey to India in pursuit of Buddhist scriptures.

The year 622 is identified as the starting year of the Islamic Calendar. The Islamic prophet Muhammad began to build mosques in Medina.

Around the mid-eighth century, *The Classic of Tea* (*Cha Jing*) was written by a Chinese writer named Lu Yu (733–c. 804). It is the first known monograph on tea in the world.

In the mid-eighth century Euclid's *Elements* was translated into Arabic.

In the late fifteenth century and mid-sixteenth century, movable type printing was popular in printing mills in China's southern provinces.

In 1504, Michelangelo (1475–1564) completed the marble statue named *David*.

In 1578, Li Shizhen (1518–1593) completed his master piece *Compendium of Materia Medica* (*Bencao Gangmu*).

In the mid-sixteenth century, construction began on the Humble Administrator's Garden (Zhuozheng Garden) in Suzhou, Jiangsu Province.

In 1590, Galileo Galilei (1564–1642) conducted the experiment on the law of gravity.

In 1605, *Remarkable Examples of Western Writing*, written by Matteo Ricci (1552–1610), was published in Beijing. Latin alphabets were introduced in China and Latin was used as phonetics for the Chinese characters.

In 1609, for the first time Dutch East India Company shipped tea from China to Europe.

In 1605 the first volume of *Don Quixote*, written by Miguel de Cervantes Saavedra (1547–1616), was published.

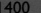

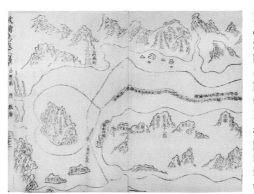

In the early fifteenth century the Treasure Ship commissioned by Zheng He (1371–1433) for his seven voyages to the Pacific Ocean. It could carry about a thousand passengers, making it the biggest ship in the world at the time.

In 868, the *Diamond Sutra* was printed with woodblock printing, making it the first printed book of this kind ever found in China.

In the ninth century, Katakana syllabary was derived in Japan by using Chinese character components, while Hiragana syllabary was derived from cursive script.

In 1420, China's Forbidden City was built in Beijing.

In 1455, Gutenberg successfully printed *The 42-Line Bible* using moveable printing, making it the first book of this kind in the West.

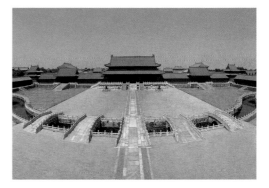

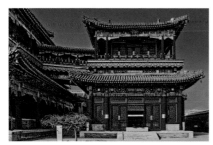

In 1694, the Yonghe Lama Temple was built in Beijing, China.

In 1617, the Ming Dynasty novel *The Plum in the Golden Vase (Jinping Mei)* was in print for the first time.

The mid-seventeenth century saw the rise of Japanese popular culture such as puppet shows, dancing geicha and novels.

In 1653, the oldest public library in the English speaking world was built in Manchester, England.

In 1687, in his *Mathematical Principles of Natural Philosophy*, a.k.a. the *Principia*, Isaac Newton (1643–1727), proposed important theories such as the theory of universal gravity and the three laws of motion.

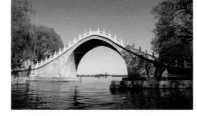

In 1782, the compilation of the first part of the *Complete Library in Four Sections (Siku Quanshu)* was completed. It is the largest collection of books in Chinese history, which included a collection of 3,461 titles of books in 79,309 volumes, and a list of 6,793 book titles in 93,551 volumes.

In 1750, construction began on the Summer Palace in Bejing, China.

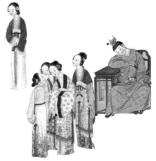

In the mid-eighteenth century, Chinese writer Cao Xueqin (c. 1715–c. 1763) wrote his novel *The Dreams of Red Chamber (Honglou Meng)*.

In 1751, *The Age of Louis XIV* was written by Voltaire (1694–1778).

In 1771, *Encyclopaedia Brittanica* was first published in Edinburgh, Scotland.

CHRONOLOGY OF CHINESE DYNASTIES

Primitive Society (c.10 million years–c. 2100 BC)

More than c.10 million years ago anthropoids lived at the edge of the forests in Lufeng, China. They are considered direct ancestors of human beings. About 1.7 million years ago sinanthropus Yuanmouensis of the Paleolithic age started to walk upright, use fire and make simple stone tools. About 10,000 years ago the Paleolithic period evolved into the Neolithic period. Human relics of the Neolithic period have been found across in China but were primarily located along the Yangtze River, Yellow River and Liao River areas. In the Hemudu Culture along the Yangtze River area, rice was cultivated and produced in abundancy; and the skills in making stone wares and pottery reached a considerable standard. The Yangshao Culture along the middle and upper reaches of the Yellow River seemed to be more sophisticated, as was demonstrated by the use of painted pottery.

Xia Dynasty (c. 2100–c.1600 BC)

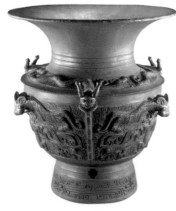

Xia is the first dynasty in recorded Chinese history. Historians often believed it to be a nation consisting of a league of tribes. Its level of civilization was less sophisticated than that of the Neolithic period, but more so than remote antiquity.

Shang Dynasty (1600–1046 BC)

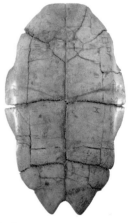

Following the Xia, the Shang became the second dynasty that adopted the system of inherited ruler-ship. The earliest written record of Chinese history is found in the Shang Dynasty, whose oracle bone scriptures, the earliest form of written Chinese language, have vivid descriptions of social activities and cultural phenomena such as rituals of worship, farming and hunting, warfare and relying on astronomical phenomena for human benefits. The Shang Dynasty was renowned in the Bronze Age for its remarkable skills in bronze making.

Zhou Dynasty (1046–256 BC)

The Zhou Dynasty was divided into the Western and Eastern Zhou dynasties. The Western Zhou Dynasty (1046–771 BC) established its capital in Haojing, near today's Xi'an, Shaanxi Province. In 770 BC Emperor Zhouping relocated the capital to Luoyi, today's Luoyang, signaling the beginning of the Eastern Zhou Dynasty (770–256 BC).

The Eastern Zhou Dynasty witnessed the first great disruption in Chinese history.

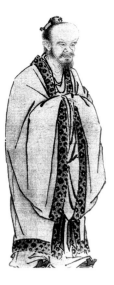

The period between 770 BC and 476 BC is called "the Spring and Autumn," when the Dukes or Princes under the Emperor vied for supremacy and ended up establishing separate states. The period between 475 BC and 221 BC is called "the Warring States." It saw smaller states being taken over, leaving only seven large states (Qin, Chu, Yan, Han, Zhao, Wei and Qi) known as "the seven powerful states of the Warring States Period." It was also in the "Spring and Autumn" and the "Warring States" that a hundred schools of thoughts emerged.

Qin Dynasty (221–206 BC)

Close to the end of the Warring States Period (475–221 BC), Qin eliminated the six remaining states, making China a unified state. In 221 BC Emperor Yingzheng

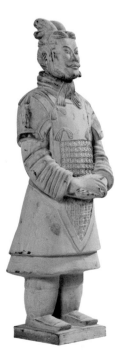

instituted a system of centralized government to replace the previous system of enfeoffment. He made Xianyang his capital and proclaimed himself the First Emperor of China (Qin Shihuang). Thus the Qin became the first unified empire in the history of China with a centralized government. The First Emperor of Qin also instituted a series of political measures that were to have a profound repercussion on the subsequent feudal systems in China.

Han Dynasty (206 BC–220 AD)

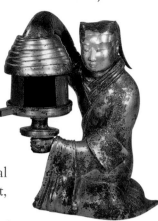

The Han Dynasty was divided into two dynasties: the Western Han (206 BC–25 AD) and the Eastern Han (25–220). In this period China's comprehensive national power reached a height, and great progress and developments were made in areas such as handicrafts industry, commerce and natural sciences. With the advent of the Silk Road China began its significant commercial and diplomatic relationship with countries in Western Asia.

Wei, Jin, and Northern and Southern Dynasties (220–589)

This period saw the most frequent power struggles in the history of China. The term "Wei, Jin, and Northern and Southern Dynasties" is a general one, which in fact consisted of the Three Kingdoms Period (220–280), the Western Jin (265–316), the Eastern Jin (317–420), and the Northern and Southern Dynasties (420–589). The enduring feud and political turmoil also brought about unprecedented economic convergence between the north and the south, as well as the mixing of different cultures and ethnicities. The culture of China's Central Plains was disseminated to southern China, and the cultures from

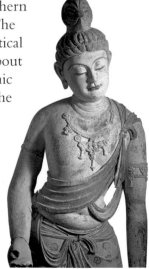

the Western Regions were also imported to China in great abundance. Buddhism that had been brought to China during the Han Dynasty was spread far and wide across the country, and gradually became an important component of Chinese ideology.

Sui Dynasty (581–618)

In 581, a man named Yang Jian ascended the throne, signaling the start of the Sui Dynasty. He established the Sui Dynasty and unified China, putting an end to the Wei, Jin, and Northern and Southern Dynasties. Great turmoil and discord had lasted more than three and a half centuries during that time. The construction of the Grand Canal linking Beijing and Hangzhou in Zhejiang Province, one of the greatest undertakings in Chinese history, was completed during the Sui Dynasty, making it a north-south bound water transportation artery. This was a tremendous breakthrough given the limited forms of transportation at the time. With the advent of the canal, connection between the north and the south was strengthened and national culture and economy benefited as a result.

Tang Dynasty (618–907)

The Tang Dynasty experienced a period of social stability and economic boom. Frequent cultural exchanges were made with many countries in the world. Japan and Korea

in particular sent students to Chang'an (today's Xi'an), the Tang capital, to study Chinese culture. These people were called "emissaries to the Tang." This period also witnessed outstanding accomplishment in the arts, such as painting, calligraphy, music and religion. The Tang Dynasty is therefore considered one of the most prosperous dynasties in Chinese history.

Five Dynasties and Ten Kingdoms (907–960)

After the fall of the Tang Dynasty, China lapsed into a brief period of tangled warfare. Five dynasties emerged one after another in the Central Plains, namely the Later Liang (907–923), the Later Tang (923–936), the Later Jin (936–946), the Later Han (947–950) and the Later Zhou (951–960), and ten separatist states spread across the west of Sichuan, the lower Yangtze River Reach, south of the Five Ridges and east of the Yellow River. This situation became known as the Five Dynasties (907–960) and Ten Kingdoms (902–979).

Song Dynasty (960–1279)

Song Dynasty was divided into the Northern Song (960–1127) and Southern Song (1127–1279) dynasties. The founding of the Northern Song Dynasty put an end to the disunity that had started by the end of

the Tang Dynasty. Such enduring discord never appeared again in Chinese history. Great progress was made in terms of social productivity, as well as science and technology, culminating in the invention of movable clay type printing and the utilization of gun powder for the first time in military affairs. The style of literature, painting and calligraphy at this period was less garish, more characteristics of the Chinese literati.

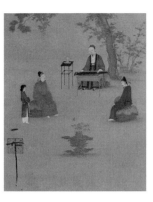

Yuan Dynasty (1279–1368)

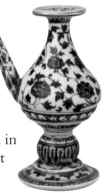

Yuan was ruled by the Mongols. It was a time when China occupied the largest territory in history. Urban business boomed at this time. Cities such as Dadu (today's Beijing) in the north and Hangzhou in the south became important commercial centers. The emergence of the Silk Road over the sea accelerated the prosperity of foreign trade in the Yuan Dynasty. Quanzhou in Fujian Province was the most important trade and transportation center at that time.

Ming Dynasty (1368–1644)

Ming is the last feudal kingdom under the rule of the Han ethnicity. Its capital was located in today's Nanjing, Jiangsu Province. In 1406, Zhu Di, Emperor Chengzu (1360–1424), the third emperor of the Ming

Dynasty, began to build the Forbidden City of Beijing, where he later relocated its capital in 1421. Techniques in making fire arms, which had first been developed in the Song Dynasty, reached very high standards. Zheng He's voyages to the West demonstrated to the world Ming China's shipbuilding technology and navigation power. China was well ahead of other countries in this respect. At this time the handicrafts industry also prospered and Jingdezhen in Jiangxi Province became the center of porcelain making. Cities saw a commercial boost and population multiplied.

Qing Dynasty (1644–1911)

Qing is the last Chinese dynasty that employed the institution of a centralized government. It was ruled by the Manchurians, but its various institutions were inherited from the Ming Dynasty, except for a few details where the Manchurian customs were retained. The Qing government also implemented a series of policies aiming to assimilate the Manchurians into the Han culture so that the Hans and the Manchurians could live in harmony. As a result, Qing's economy expanded and people benefited from the strong national power. Agriculture and handicraft industry reached the highest sophistication at this time.

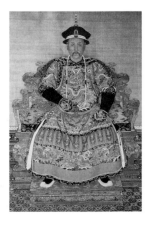

CHINESE ANCESTORS

The Period of Primitive Existence

China is one of the oldest countries in the world. Traces of human lives that lived as early as over two million years ago have been found in the vast expanse of Chinese territory. Early forms of homo erectus, such as the Yuanmou Man, the Lantian Man, Beijing Man, Hexian Man and Tangshan Man, who lived around the Paleolithic era, are found to have concentrated in northeastern China, the Central Plains and southern China. A great number of human fossils excavated at Zhoukoudian in Beijing, where the Beijing

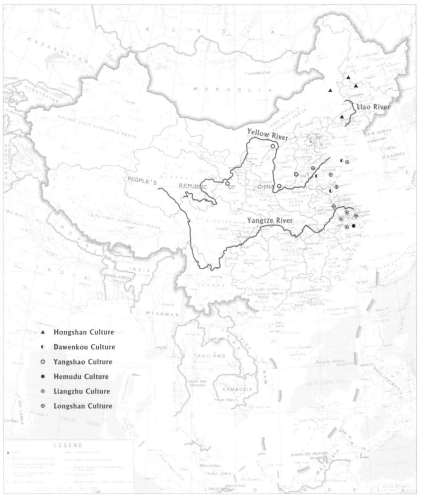

▲ Hongshan Culture
◔ Dawenkou Culture
○ Yangshao Culture
● Hemudu Culture
⊙ Liangzhu Culture
⊕ Longshan Culture

LEGEND

◀ **Map of Cultural Relics of the Neolithic**
The valleys of Yangtze River and Yellow River, favored with a mild, humid climate and fertile land, were physically conditioned to be the cradle of the Chinese nation. Sites of human cultural relics that date as far back as the Neolithic period were found across the country but mainly spread along the valleys of the Yangtze River and Yellow River, and sometimes the Liao River valley.

GS(2006)1475

Man lived about 700,000 to 200,000 years ago, played an important role determining the human evolution from ape-like men to modern humans. It was about 10,000 years ago that human activities moved from caves to bench terraces and the plains, and that Paleolithic society evolved into Neolithic society. Around 8,000 BC polished tools were widely used by primitive people living in China and sedentary agricultural life began to take shape.

Archaeological findings have indicated that Chinese ancestors who lived 8,000 to 10,000 years ago had used earthenwares on a daily basis and learned to cook food with fire. They had invented transportation vehicles such as boats, and learned to grow a species of millet, broomcorn millet and rice. They made production tools out of animal bones and started to domesticate animals. Their primitive culture and arts consisted of beautiful designs and signs carved and painted on their earthenwares to record events. As the powers of nature were overwhelming, Chinese ancestors sought protection from the Gods with supernatural powers through practicing primitive religion such as totem worship.

The Liao River Valley

5,000–3,000 BC
Hongshan Culture

Five to six thousand years ago Yangshao Culture in the Central Plains came to contact with the northern pastoral culture in the west of Liao River valley. As a result of such interaction, Hongshan Culture, which was vibrant and full of creativity, lasted for as long as two thousand years. The social structure of Hongshan Culture was characterized by tribal groups being based on the blood of females. The skill of jade working was highly developed at this time. Jade artefacts, polished out of jade stones with smooth and shining surfaces, were executed in such a way that they were brimming with a spirit of their own. The manufacture of jadeworks showed signs of development in a professional and systematic manner.

▶ **Jade Dragon**
(Hongshan Culture)
Close to a hundred pieces of jade crafts have been unearthed so far. The jade dragon here is an artefact representative of jade works in the Hongshan Culture. It is also one of the early images of dragon that have been excavated in China. To the Chinese, the dragon represents gods and spirits. The excavation of the jade dragon indicates that the Chinese ancestors had already developed a sense of worship toward dragons at the time.

The Yellow River Valley

4,300–2,400 BC
Dawenkou Culture

Dawenkou Culture was also characterized by an economy of agriculture. Millet, a crop for dry soil, was cultivated. Artefacts made of pottery, stone, jade and bone showed highly developed craftsmanship. The early and middle periods of the Dawenkou Culture were matriarchal but later became patriarchal.

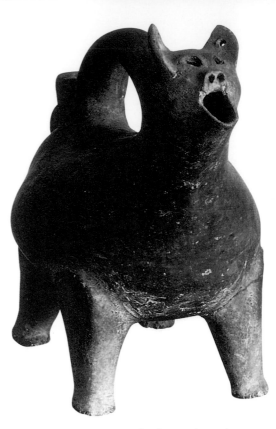

▼ Painted Boat-Shaped Pot
(Dawenkou Culture)
The pot, with fishing net decorated on each side, created an image of two fishing nets hanging on both sides. Such a design indicates that fishing was one way to gather food for Chinese ancestors living in the Neolithic.

▲ Animal-Shaped Red Pottery Pot
(Dawenkou Culture)
Modeled in the shape of a swine with its mouth open, the pot was practical and also considered a work of art. It marked the cultural attainment of prehistoric China.

4,800–2,700 BC
Yangshao Culture

The two-thousand-year old Yangshao Culture was one of the earliest Neolithic cultures found in China. It occupied a vast territory and was characterized by its outstanding cultural accomplishments. At that time people began to settle in places for longer periods of time and learned to grow crops that were good for dry soil, such as millets and broomcorn millets. Agriculture became the predominant economic life. They also learned to weave nets, catch fish with fishing nets and domesticate animals. This period was considered the height of the matriarchal tribal society.

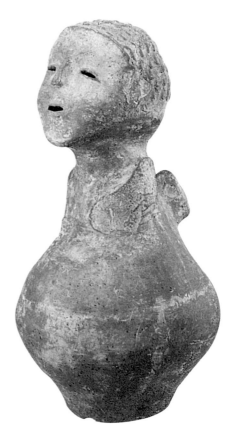

▲ A Pot Topped with a Human-Head-Shaped Closure

(Yangshao Culture)
With great wisdom, primitive Chinese people depicted, in various potteries, their vision of the world. The animals, plants and human beings themselves on those small potteries reflect their appreciation for beauty as well as their rich spiritual world. This Neolithic red pottery container shows a maiden with a serene look on her face. It is a perfect combination of artistic value and practical use.

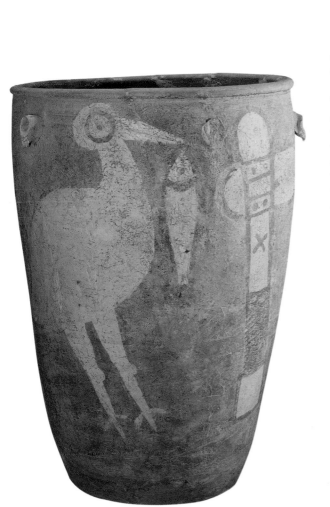

◄ Pottery Jar Painted with a Stork, a Fish and a Stone Axe

(Yangshao Culture)
Uncovered at the site of Yangshao Culture, the jar is decorated with a stork, a fish and a stone axe, a design considered to be one of the earliest forms of painting in China. Its body is light orange, the stone axe and its wooden handle white, and different shades of brown are used to color the stork, the fish's eye, the coiled rope on the handle, and the fish's tail, fin and back. Only three colors were employed to create a picture that is bright and pleasing to the eye. The picture also reveals some of the basic techniques used in Chinese painting, such as Correspondence to the Object (the depicting of form, which includes shape and line), Bone Method (the way of using the brush) and Suitability to Type (the application of color).

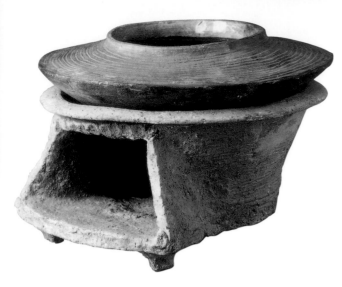

▲ Pottery Cooking Utensils

(Yangshao Culture)

Archeologists have found traces of fire at sites of primitive human relics that date back to about one million and seven hundred thousand years ago. The use of fire, first natural and then man-made, constitutes an indispensable part of human evolution. This set of cooking utensils, uncovered at the site of Yangshao Culture four to five thousand years ago, testifies that cooking with fire had become a principal means of food processing in the lives of Chinese ancestors.

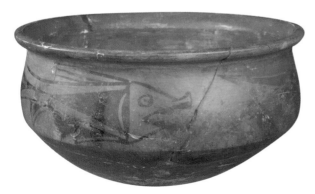

▲ Painted Pottery Bowl with Fish Decoration

(Yangshao Culture)

Yangshao Culture is also known as "a culture of painted pottery." Pottery was hand-made of white, red and gray sand. They were painted black against a red background. They came in a variety of shapes, all with rich designs such as fish, deer and sheep painted on their surfaces. The pottery bowl here is a typical example of vessels of Yangshao Culture. The design on the bowl depicts two fish chasing one another, suggesting the importance of fishing in people's economic lives at the time.

10,000–8,000 BC
Longshan Culture

The Longshan Culture was a late Neolithic Culture in the middle and lower Yellow River Valley areas of northern China, including today's Henan, Shandong and Shanxi provinces. This culture was noted for its exquisite black pottery.

The spout resembles the head and the mouth of an animal.

The handle looks like the tail of an animal.

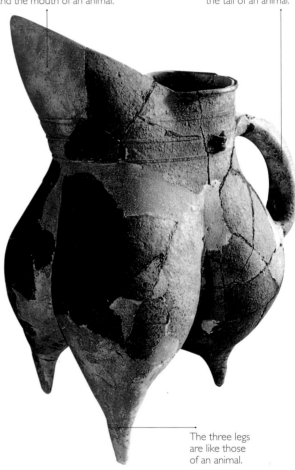

The three legs are like those of an animal.

▲ Pottery Pitcher

(Longshan Culture)

Chinese ancestors learned to make pottery as early as 8,000 to 10,000 years ago. A pottery vessel shaped like this one here is called *gui*, a vessel for holding water. The shape was inspired by that of an animal. The three legs (*zu* in Chinese means abundance and contentment), short and stout, expresses people's wish for a good harvest. This design also testifies to Chinese ancestors' animal worship.

The Yangtze River Valley

5,000–4,000 BC Hemudu Culture

A brilliant primitive culture that originated from the Yangtze River Valley. Hemudu Culture was characterized by various production tools made of stones, bones and wood. Remains of rice were found on a number of occasions, which was indicative of agriculture as its primary economy.

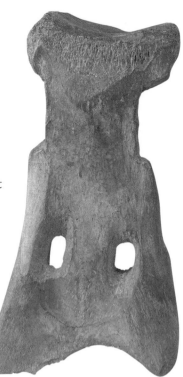

◀ A Farming Tool Made Of Bone (*Gusi*)

(Hemudu Culture)
China is one of the first countries that developed agriculture. Millets and broomcorn millets were cultivated in the Yellow River valley seven thousand to eight thousand years ago at the latest. Agricultural implements made of bones were widely used for production. People used animals' shoulder blades and hipbones to make various farming tools, such as plowing blades, hoes and spades. These tools were light and convenient for farming at paddy fields. A spade-shaped tool, *gusi*, was widely used as a plowing implement in the Yellow and Yangtze River valleys.

3,200–2,000 BC Liangzhu Culture

Originated from the Lake Tai area in the lower reaches of the Yangtze River, the Liangzhu Culture was known for its highly developed agriculture, animal domestication and handicraft industry. Archeological research has found a great number of finely-crafted jade artefacts from this period.

▼ Mountain Shaped Jade Decoration

(Liangzhu Culture)
A number of finely-crafted jade artefacts were uncovered at the sites of Liangzhu Culture. Most of them were used as offerings to gods or ancestors and as objects for burial chambers. These objects reflect the primitive religious faith at the time. The mountain shaped jade decoration here was decorated with faces of god, human and animal, which is typical of jade artifacts of the Liangzhu Culture.

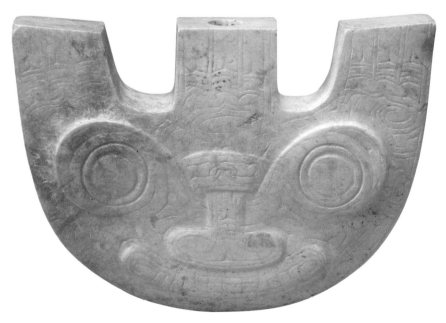

THE DAWN OF CIVILIZATION

Dynasties of Xia, Shang and Zhou

Historically, Xia, Shang and Western Zhou are the first three dynasties which succeeded one institution after the other. Along the way came a series of scientific and technological inventions, the advent of a written language, as well as the formation of moral standards. All these developments indicated that China had officially entered a civilized era.

Around 2100 BC, the Xia people grew increasingly powerful and eventually brought under control a great proportion of the middle reaches of the Yellow River. Yu, the chief of the Xia people, passed his title to his son, Qi, who later founded Xia—the very first kingdom in the history of China. Around 1600 BC, the Xia Dynasty began to decline and the Shang people rose up and brought all the tribes together and established the Shang Dynasty. Around 1046 BC, the Zhou people overtook Shang and set up the Zhou Dynasty. Haojing, near today's Xi'an in Shaanxi Province, was selected as its capital.

People of the Xia, Shang and Zhou dynasties found solace in the gods of heaven, deities on earth and the spirits of the dead. They believed that the emperor or king on earth was authorized to rule with the "Mandate of Heaven." As a result, rituals of worship were an important part of their lives. Bronze, as precious as gold today, was used to make ritual vessels for holding wine, food and water to feed their ancestors, as well as musical instruments to greet the gods and

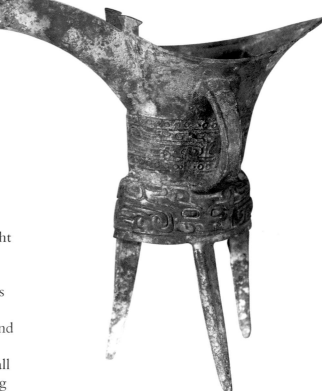

▲ **Wine-Heating Vessels**
The spout is cleverly molded in the shape of a beast's head.

the spirits. Bronze was also used to make weapons for national defense or accessories to protect their masters in burial chambers. All this constituted a splendid bronze culture. The Shang people inscribed their divinations on the oracle bones and these inscriptions became the forerunner of modern Chinese scripts.

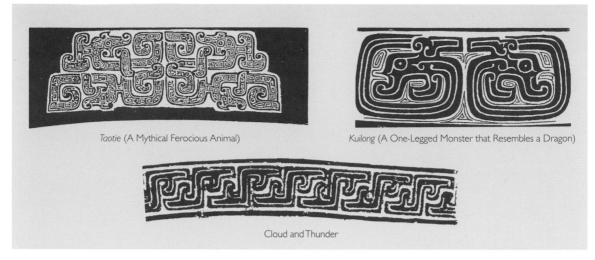

Taotie (A Mythical Ferocious Animal)

Kuilong (A One-Legged Monster that Resembles a Dragon)

Cloud and Thunder

▲ Illustrations of Bronzeware Decorations

▼ Food Vessels

Starting from the Shang Dynasty, bronze vessels came to be regarded as symbols of their owners' social statuses and identities. They were widely used in political life and ritual ceremonies. Ritual bronze vessels in the Shang and Zhou dynasties were mainly vessels holding food, wine and water. They were bulky with complex decorations. Among them, ding, three-legged (round) or four-legged (square) vessels with two handles, were the most important ritual vessels signifying power and status.

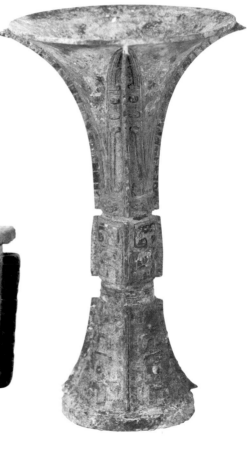

▲ Wine-Drinking Vessels

This vessel, *gu*, is made for wine drinking. It has a slender body, a thin waist, a long foot and an opening like that of a trumpet.

▼ Jade Artifact—*Cong*

The ancient Chinese believed that the Earth was square and the Sky was round. This cylindrical jade artefact, which looks square from the outside and round in the inside, is called *cong*. It was one of the important ritual vessels, primarily used in worshipping the Earth. It also symbolized power.

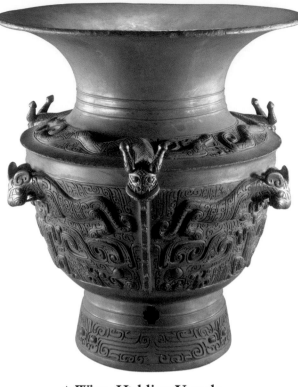

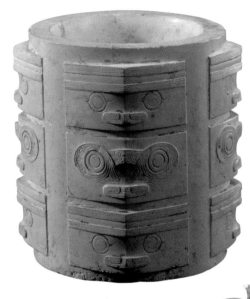

▲ Wine-Holding Vessels

This item is called *longhu zun* (bronze vessel with dragon and tiger decoration), used mainly to hold wine at ceremonies such as worships and feasts.

▲ Pendant *Huang* Decorated with Dragon Heads and Grain

In the Western Zhou Dynasty jade wares began to be associated with social hierarchy and became a symbol of social status. Like the bronze ware, the use of jade ware followed a strict rule of social stratification. This jade arch here, called *huang*, was used in the worship of the God of the North. Its two ends are carved with the head of a dragon, and its entire body has neat rows of grain pattern carved in relief, representing the wish for good weather for the crops and a bumper harvest.

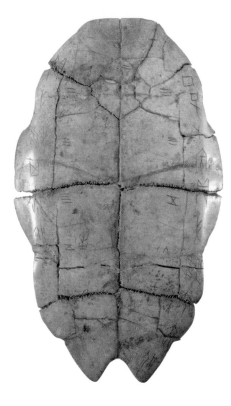

Comparison of Ancient Styles of Calligraphy								
Small Seal Script	Western Zhou Dynasty (1100BC-771BC)	Warring States Period (475BC-221BC)						
		Qin	Chu	Qi	Yan	Three Jins	Zhongshan	
马								
者								
市								
年								

◄▲ Oracle Bone Scripts: the Earliest Chinese Scripts

Oracle bone scripts are the first records of Chinese scripts that have been found so far. It is thus named because the scripts were inscribed on the carapaces of tortoises and bones of animals such as bulls and sheep. The scripts are usually records of divinations. Archeological findings show that there were over five thousand individual graphs on the unearthed Shang oracle bones (around the thirteenth century). Oracle bone scripts testifies to a well-developed writing system that has enabled the Chinese to create scripts, such as pictograms, logical aggregates, pictophonetic compounds, borrowing and ideograms.

Inscriptions, representing the owner of this bronzeware.

▼ Rubbings of Inscriptions on Bronze Wares

The Shang people inscribed words on the bottom or the sides of a bronze ware. The inscription could be as few as one or two characters, or as many as twenty or thirty. These scripts are called *jinwen* (bronze script). When the Western Zhou was founded in the eleventh century, inscriptions on bronze wares became more common and gradually replaced the oracle bone scripts. The bronzeware scripts carried forward some of the characteristics of oracle bone scripts but differed in the formation of strokes. What was recorded in bronze scripts often included such things as ceremonial texts, the emperor's orders, incidents of killing and funerals.

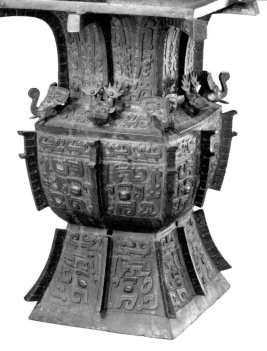

▲ Decorations with Animals

A major decoration on the Shang ritual bronzeware is an animal called *taotie* from ancient legend. The use of such mysterious animal as decoration is an embodiment of the austerity and social status of their master.

THE ORIGIN OF ORIENTAL CULTURE

The Spring and Autumn and the Warring States Periods

In 770 BC Emperor Ping of the Zhou Dynasty relocated the capital to Luoyi (today's Luoyang, Henan Province), marking the beginning of the Eastern Zhou. Eastern Zhou was divided into two periods, the Spring and Autumn Period (770–476 BC) and the Warring States Period. In the 295 years of the Spring and Autumn Period, more than 400 wars of considerable scale were recorded in historical documents. This on-going separatist warfare resulted in smaller states being taken over by larger ones. At the same time, larger states quickly expanded their territories and over time only seven large states were left in the Warring States. They were Qin, Chu, Yan, Han, Zhao, Wei and Qi.

The turbulence in the Spring and Autumn and the Warring States periods didn't stop people's guest to pursue the meaning of life. In the fifth century BC China witnessed the first golden era of lively ideological and cultural developments in its history. This was regarded as a period of the "Hundred Schools of Thought."

For the past thousands of years, Taoist philosophy, represented by Laozi, and Confucianism, founded by Confucius, have pervaded every aspect of life in China, creating a profound influence on the people's characters and political views. The doctrines of Laozi went beyond the realm of morality and ethics, life and politics, to aspects of the whole universe. His ideological system had an impressive and influential effect on ancient Chinese politics, military, religion and medicine. Confucius, however, advocated that "letting the ruler be a ruler; the minister be a minister, the father be a father, and the son be a son." Confucian doctrines revolved around the concept of human relations, and he explored various means to attain social order and harmonious human relationships. His effort was recognized and appreciated by feudal rulers and Confucianism became the strongest driving force in the development of Chinese philosophy.

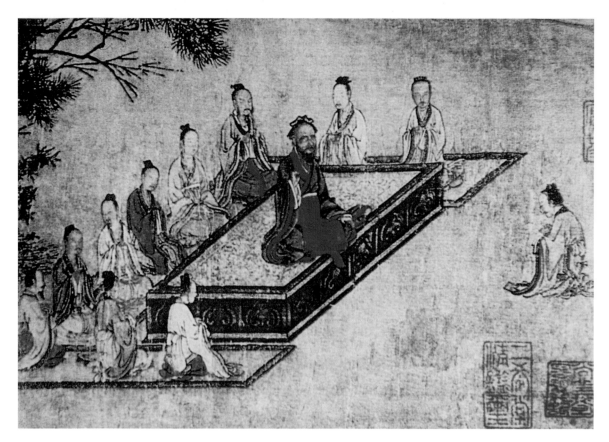

▲ Confucius and His Disciples

This picture depicts Confucius is giving a lecture to his disciples. Confucius introduced the idea of private education, for he believed that everyone was entitled to education. He was said to have as many as three thousand pupils, among whom seventy-two attained outstanding achievements.

▶ A Page from the *Analects*

The *Analects* is a collection of saying by Confucius and his pupils pertaining to his teachings and deeds. It embodies the most important doctrines of Confucius, the founder of Confucianism. The *Analects* is one of the earliest Confucian classics.

◀ Confucius

Founder of Confucianism. He advocated "propriety and righteousness," "ceremonies and music" and "good government that rules by virtue and moral example." His philosophical ideas have far-reaching impact and have penetrated all aspects of Chinese life and Chinese culture.

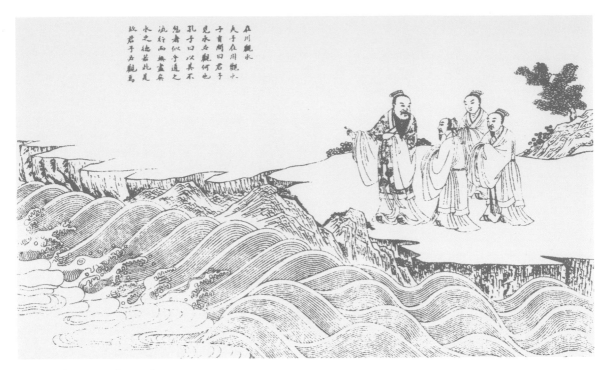

▲ Confucius Thought

When Confucius died, his disciples compiled
a book named the *Analects*, a collection of
Confucius's sayings pertaining to his teachings and
deeds. There are many incisive teachings regarding
the philosophy of life in this book. The picture
here depicts Confucius, standing by a river, telling
his pupils: "Time passes, like this rolling river,
never ceasing day or night."

▶ "Ten Offerings of the Shang and Zhou Periods"

Confucius stressed human relations at the outset
and resolved to establish a peaceful society
where people lived in harmony. His thought
eventually won recognition from the rulers. As
a result Confucius and his family were treated
with courtesy by a succession of emperors. Qing
Emperor Qianlong (1711–1799) offered the
Temple of Confucius ten pieces of the Shang
and Zhou bronze wares that had been kept in the
interior court of the royal palace to be used as
sacrifice to Confucius.

▶ Bell and Music

A musical instrument made of bronze. Bells like this played an important role in the activities of worship and warfare in ancient China. In the Western Zhou Dynasty, music and ceremonies were very sophisticated, but by the Spring and Autumn Period in which Confucius lived, all previous social orders and moral standards were falling apart. When confronted with the demise of propriety and music, Confucius sought to reinstate ceremonies (or propriety) and music that were considered to have an exemplary effect in society. He believed that "ceremonies (or propriety)" could instill order and that "music" could create harmony. Ceremonies and music were a driving force behind a harmonious society.

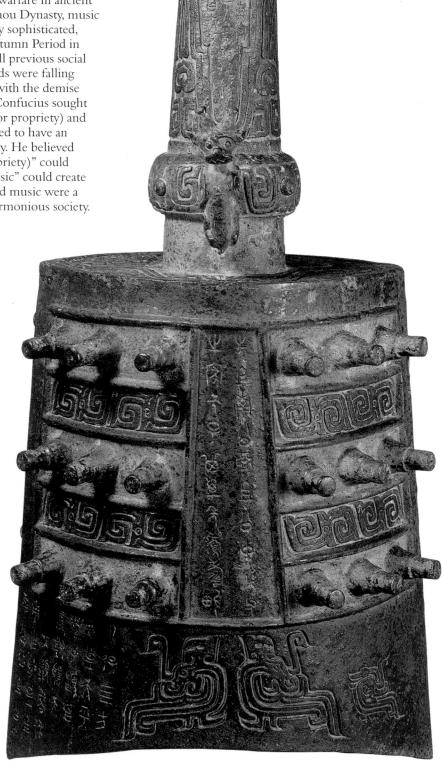

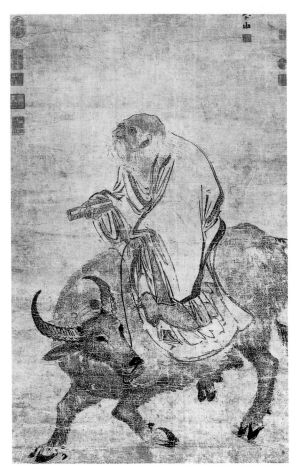

◀ Laozi

Laozi, who lived around 571 BC to 471 BC, worked as custodian of imperial archives. Upon retirement at old age, he lived in seclusion. He wrote *Classic of the Way and Its Virtue*, a little book with only 5,000 words, but it covered profound philosophical thoughts and pioneered philosophical thoughts in ancient China. *Laozi Riding an Ox* by Zhang Lu (Ming Dynasty), collected in the Palace Museum, Taibei.

▼ The Very High Lord

Taoism, founded in the Eastern Han Dynasty, is a home-grown religion based on Laozi's ideological system. It advocates tranquility and non-action, the cultivation of moral character and inner essence. Laozi was highly respected and regarded as the founder of Taoism and known as the "Very High Lord."

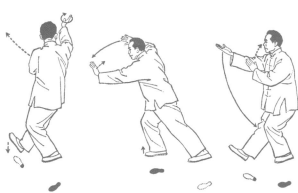

▲ *Taiji Quan* (or Shadow Boxing)

According to Laozi's dialectical doctrine, the seemingly opposing elements of non-being and being, unreality and reality, yin and yang, hard and soft, activity and tranquility rely on each other and can also transform to the opposite so that the weak overcomes the strong and that the tender overcomes the hard. *Taiji quan*, the quintessence of Chinese martial arts that emphasizes the doctrine of the weak and tender overcoming the hard and the strong, is inspired by the thought of Laozi.

▲ The Rochet of Taoism

When a religious rite is in session, the Taoist priest puts on a special robe, i.e. the rochet. The rochet is usually apricot and blue embroidered with designs such as dragons, the Eight Diagrams (eight combinations of three whole or broken lines formerly used in divination) and white cranes. A crane is a Taoist mascot that symbolizes longevity and good fortune.

▶ The Eight Immortals of Taoism

Worshipping supernatural beings is one of the Taoist characteristics. The Eight Immortals, who had been mortals but turned immortal through practicing Taoism, are worshipped by Taoists. It is also a popular element in Chinese folk literature. The Eight Immortals are Zhong Liquan, Elder Zhang Guo (Zhang Guolao), Lü Dongbin, Iron Crutch Li (Li Tieguai), Immortal Woman He (He Xiangu), Lan Caihe, Philosoper Han Xiang (Han Xiangzi) and Royal Uncle Cao (Cao Guojiu). The paper cut here is the Chinese character *shou* (longevity). The Eight Immortals are painted on the lines and strokes of this character.

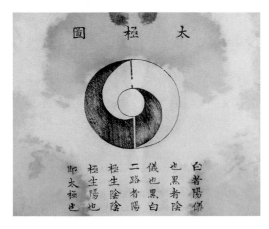

◀ The Diagram of the Great Ultimate

As founder of the philosophical system emphasizing "Tao," Laozi believed that "the ten thousand things carry the yin and embrace the yang," which illustrates two opposing forces that actually rely on each other for existence and are likely to convert to each other. The diagram of the Great Ultimate reflects the essence of Laozi's dialectical thought: the two colors, black and white, represent yin and yang, Earth and Heaven; where the black and the white converge is where humans are.

Beacon Tower
Beacon tower was one of the defense systems of the Great Wall. Specially trained personnel were posted in the tower day and night. In case of emergency smoke was used in the day and fire at night to convey military information.

THE FIRST FEUDAL DYNASTY IN CHINA

Qin Dynasty

Qin was an ancient nomadic clan. During the Xia Dynasty, the Qin people lived by the East China Sea in the lower reaches of the Yellow River and were granted the surname "Ying" by the royal family. Later in the Shang Dynasty, they moved westward to the eastern part of Gansu Province, mainly living on livestock. They didn't settle down until the Western Zhou Dynasty when they submitted to the Zhou. In 770 BC, Qin was conferred a prince and given territory for assisting the King of the Zhou in moving eastward, thus making its formal debut on the historical stage.

221 BC saw the founding of a unified empire for the first time in Chinese history. This empire, with a centralized government and multiple ethnic groups, was brought into being by Emperor Qin Shihuang (259–210 BC), the first emperor of China. Two thousand years had gone before the Qin people brought separate states under one ruler. They started as nomads, then settled down and eventually rose to the challenge of unifying China. The Qin prince had fought far and wide during the Warring States Period, conquering six feudal states, including Han, Wei, Chu, Yan, Zhao and Qi, and, after ten years, founded a unified Qin Dynasty. The establishment of the Qin Dynasty marked the end of the destructive civil wars that had been going on since the Warring States Period and henceforth China entered a new period of social development.

Emperor Qin Shihuang started a nationwide reform that was to have incalculable impact on subsequent history of China. He inaugurated the title "Emperor" or *huangdi* in Chinese and called himself *shihuangdi*, literally the First Emperor (in Chinese, *shihuangdi*, same with *shihuang*). He initiated the system of a centralized government with an emperor having paramount power. He started the use of a unified written language across the country, unified currency, and commonly recognized system of weights and measures. A great many projects of spectacular scales were under way during his reign: the construction of the imperial trunk roads, Lingqu Irrigation System, the Great Wall, the mausoleum of the Emperor, just to name a few. They were all projects of enormous undertaking even by today's standard. The First Emperor, as well as the Qin Dynasty he established, left a colorful imprint on history of China.

◄ The Great Wall Constructed in the Reign of the First Emperor

In the early third century BC states of Zhao, Yan and Qin built walls along the border area to ward off alien invasions from the peripheral areas. In 213 BC, Emperor Qin Shihuang issued orders to repair and extend the walls previously built by the three states, making it one connected wall. This wall ended up going tens of thousands *li* (one *li* equals to roughly 415 meters) on end and was thus called the "Great Wall of Ten-thousand *Li*." The subsequent emperors also made efforts to repair the Great Wall. The part that was renovated during the Ming Dynasty has been well-kept to this day.

▶ Inaugurating the System of Emperorship

To demonstrate his supremacy, Emperor Qin Shihuang established a system of emperorship: he stipulated that all his decrees should be taken as law and that all his orders and commands as edicts, and that he himself be called *zhen*. The seal exclusively used by the emperor was made of jade with a special name *xi*. This system remained until the Qing Dynasty.

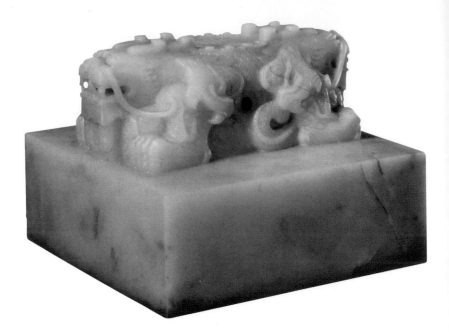

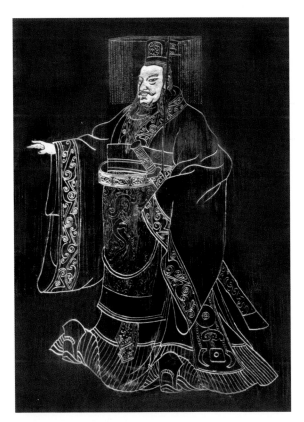

▲ A Pyramid-Like Hierarchical Structure of Government Officialdom

The Qin Dynasty adopted a political institution of centralized state power, with the emperor at the very top having supreme power and a central government below him. The core of the government was composed of three dignitaries and nine chief ministers. The three dignitaries, which included the Chief Counselor, the Grand Marshal, the Censor-in-Chief, were the highest ranking officials responsible for administration, military affairs and supervisory system; the nine chief ministers presided respectively over areas such as the affairs of the imperial family, the legislation, foreign affairs, military affairs, and finance. This pyramid of centralized state power had impact on the Chinese society throughout its feudal years.

▲ Emperor Qin Shihuang

The First Emperor was enthroned at 13, started to administer national affairs at 23, and conquered six states at 39. He founded for the first time in Chinese history a unified empire with multiple ethnic groups.

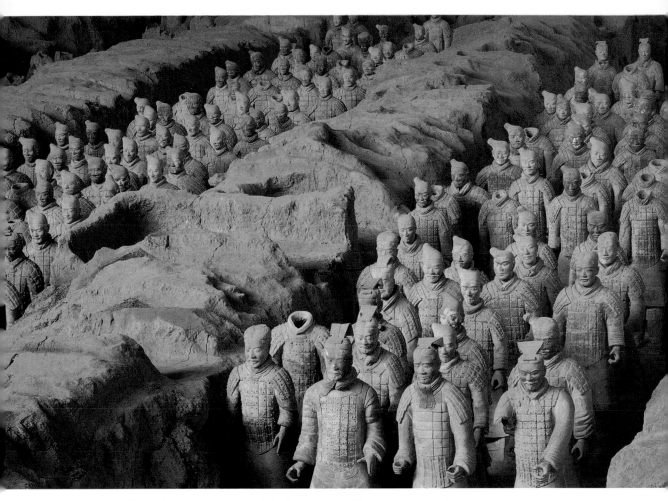

▲ Terracotta Warriors in the Burial Site

Ancient Chinese believed that human beings lived in the world of yin and yang. While alive, they lived in the yang world; when dead they lived in the yin world. They believed that their daily necessities had to go with them to their tombs when they died. There are over 400 pits in the mausoleum of the Emperor Qin Shihuang, where his daily necessities were buried, including terracotta warriors covering an area of more than 20,000 square meters. Unearthed so far are 8,000 terracotta figures, over a hundred war chariots, as well as tens of thousands of real weapons. All these testify to the military power of the Qin Empire.

▼ Bronze Sword

Bronze swords were one of the most important weapons in the Qin Dynasty. This sword was unearthed at the pit where terracotta warriors and horses were buried in the mausoleum of Emperor Qin Shihuang. The Qin law stipulated that weapons, whether made by the central government or some local authorities, had to be approved by supervisors before they were collected in the national arsenal. Should they be rejected, the officers and functionaries would be punished for it. Therefore, it was mandatory that the names of the manufacturer and the supervisor be engraved on the weapon.

▶ *Hufu* (Tiger-Shaped Tally)

Hufu, a tiger-shaped tally, symbolized imperial authority for troop deployment in the Spring and Autumn and Warring States periods. The tally was sliced in two lengthwise along the back and belly. The upper half of each piece had the same inscriptions. The right half remained kept in the imperial court and the left half was issued to the general in command. When further deployment needed, the two parts had to piece together to verify the authenticity of the *hufu*. In the Qin Dynasty verification of *hufu* was required if an army of fifty or more was to be dispatched.

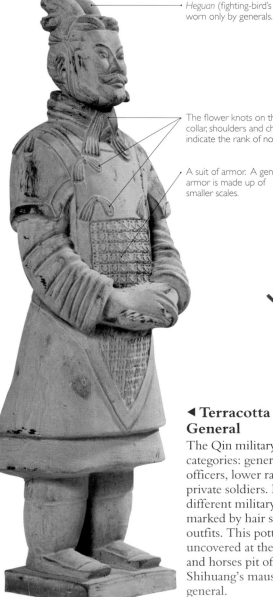

Heguan (fighting-bird's hat), worn only by generals.

The flower knots on the collar, shoulders and chest indicate the rank of nobility.

A suit of armor. A general's armor is made up of smaller scales.

▼ The Chariot Used Exclusively by the First Emperor

Unearthed from Emperor Qin Shihuang's tomb, this horse-drawn bronze chariot was called *anche* (safe chariot), the highest ranking vehicle in the Qin Dynasty. Its design was an embodiment of the ancient Chinese ideology—the Heaven is round and the Earth is square. The oval roofing symbolizes Heaven and the square carriage the Earth, and the wheel with thirty spokes is a symbol of the shining sun and moon.

◀ Terracotta Figure of a General

The Qin military ranks fell into four categories: generals, middle ranking officers, lower ranking officers and private soldiers. Distinctions among different military ranks were strictly marked by hair styles and warfare outfits. This pottery figurine here, uncovered at the terracotta warriors and horses pit of Emperor Qin Shihuang's mausoleum, was a general.

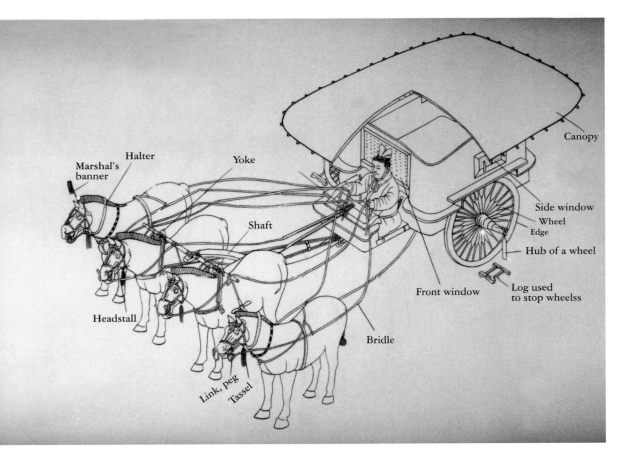

Marshal's banner

Halter

Yoke

Canopy

Side window

Wheel Edge

Hub of a wheel

Log used to stop wheelss

Front window

Shaft

Bridle

Headstall

Link, peg

Tassel

▲ The Units of Bronze Chariot and Horses No. II

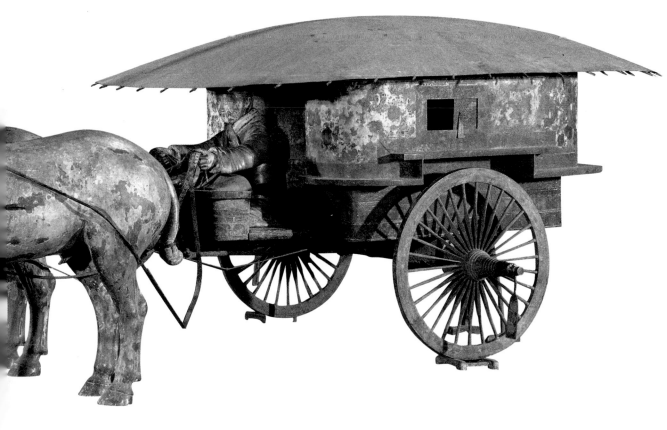

THE SILK ROAD

Western Han Dynasty

The Silk Road generally refers to the route Zhang Qian and his envoy opened up when visiting the Western Regions (the region of Central Asia west of Yumenguan Pass). It was a passageway that began in the east at Chang'an and Luoyang, via Gansu and Xinjiang, to Central Asia and Western Asia. It was an overland route that connected with the Mediterranean countries. Commodities that were transported to the west on this route were predominantly silk, so contemporary scholars named it "the Silk Road." With the advent of an overland route to the west of China's frontier, commercial contacts between China, Central Asia and Europe multiplied. Before long the Silk Road grew to be a cultural and economic path across the Eurasia Continent. In 60 BC the Han administration set up an organization directly responsible for the Western Regions—the Protectorate of the Western Regions, which marked the beginning of a prosperous period for the Silk Road. However, as internal turmoil grew, the Silk Road fell into disarray and was used only occasionally after 6 BC.

When China entered a period of prosperity in the Tang Dynasty, the Tang government named the Four Garrisons of Anxi as institutions dealing with issues regarding the Western Regions. A series of measures were taken to reinvigorate the commercial function of the Silk Road. A new fort named Yumenguan Pass was built; mountain passes and gates were reopened along the way. A branch route of the Silk Road was developed at the north of the Tianshan Mountain, while the westward road was extended to Central Asia. During this period, Lower Empire and Persia (whose

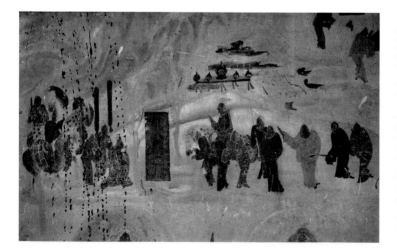

◀ Dunhuang—a Stopover Point on the Ancient Silk Road

Dunhuang Mogao Grottos lie on the eastern edge of the Taklimakan Desert, spanning 1,000 years of Buddhist art and culture along the Silk Road. The cultural treasure house contains more than 45,000 square meters of murals, over 2,000 painted statues, more than 50,000 manuscripts, and nearly 1,000 woodcuts, along with various other silk paintings, embroideries and other works of art.

hegemony in Central Asia was replaced by the Arab Empire after the mid-seventh century) maintained a relative stability. As a result, the Silk Road witnessed another period of prosperity. By the end of the Tang Dynasty after the An-Shi Rebellion and its ongoing warfare, waged by An Lushan (703–757) and Shi Siming (703–761), the pastures and oases at the northwestern part of the Silk Road were destroyed. The east end of the Silk Road was almost abandoned, whereas other ancient states at the west of China's frontier were all gone by this time. As a result, the northwestern part of the Silk Road gradually lost its function. The southern part of the Silk Road and the Silk Road on the sea, however, were developing quickly and gaining momentum in trade.

Trade Caravans on the Silk Road

For more than a thousand years, merchants of different skin colors, who dressed in various costumes, traveled frequently with their camel caravans on the Silk Road. In addition to caravans from China, there were caravans from other countries, such as Rome, Persia, Syria, Kangju and Anxi (Parthia).

Record shows that at the end of the Roman Republic when Caesar turned up dressed in silk cloak at a theatre, he was criticized for being too extravagant; but soon nobilities in Rome fell over one another in their eagerness to wear silk. Embroidered silk clothes became the fashion of the nobles. Before long markets exclusively selling Chinese silk appeared in Rome. The price of silk became so high that 600 grams worth of gold could only trade a pound of silk. The Egyptian Queen Cleopatra was a great lover of silk. She was documented as receiving diplomatic envoys dressed in silk and had a strong passion for products made of silk.

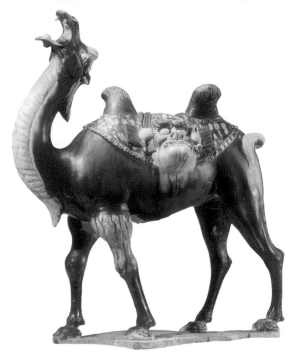

▲ **Tri-Color Glazed Squatting Camel**
This artefact depicts one of the vehicles used on the Silk Road. Traveling on the Silk Road was long and tiring so camels, horses, donkeys and mules were used as means of transportation. Camels were the most often used. The number of camels leading a large trade caravan could range to several hundred. A large caravan could be a formidable presence within the vast expanse of the desert.

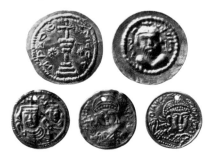

▲ **Gold Coins of the Eastern Rome**
Gold coins of the Eastern Roman Empire, currency used on the Silk Road.

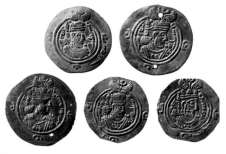

▲ **Silver Coin of Persia**
Silver coins from Persia, currency used on the Silk Road.

China—Home of Silk

China is one of the earliest countries that cultivated silkworms and produced silk. Ancient documents and archeological findings show that China has had a history of sericulture for at least 5,000 years. By the Qin and Han dynasties the production of silk reached a peak. Silk at that time fell into three kinds: *juan* (tabby weave silk), *qi* (damask), and *jin* (brocade). The advent of brocade marked an important milestone in China's silk making history as brocade integrated silk's fine qualities with the arts. It was during this time that the Silk Road came into shape. The heyday of silk production was during the Tang Dynasty when its output, quality and variety reached an unprecedented level. Silk trade boomed and the number of the Silk Road routes expanded to three.

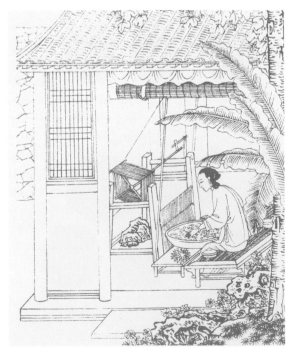

▲ *Court Ladies Preparing Newly-Woven Silk* (section), by Zhang Xuan of the Tang Dynasty

Now collected at the Museum of Fine Arts (Boston, USA), this is a painting with meticulous brushwork and strong color. It depicts a scene of court ladies preparing silk and making clothes. *Lian* is a type of silk that is initially hard, but becomes soft and white after a process of boiling, bleaching and pounding.

◄ Making Silk in *Tiangong Kaiwu* of Ming Dynasty

Completed in 1637 by Song Yingxing (1587–?), *Exploring Nature with Divine Craftsmanship* (*Tiangong Kaiwu*) is the first monograph on science and technology in the world that recorded the skills and techniques of agriculture and craftsmanship. It is credited as a "handicraft-technology encyclopedia of China in the seventeenth century." The book recorded the process of how ancient Chinese extracted long strands of silk from cocoons and wove them into fabric for clothes. "Making Silk" is taken from this book.

Going West

As the Silk Road was bustling with trade, caravans transported goods to the West such as the technology of paper making, printing, silk reeling, smelting and mining. In addition, a variety of goods was imported to the West, such as tea, jade, lacquer, bronze and iron wares, glazed pottery and musk. From the Song Dynasty onward, tea and china, as well as silk, became the three biggest exports in China. For some time, the trade of silk with linen in the Chinese frontier was replaced by the trade of tea and horses. Hetian jade was also a commodity highly sought after by the western world. The technique of paper-making, disseminated in the Tang Dynasty by the Arabs via the Silk Road to Egypt and Europe, gave a tremendous boost to world civilization.

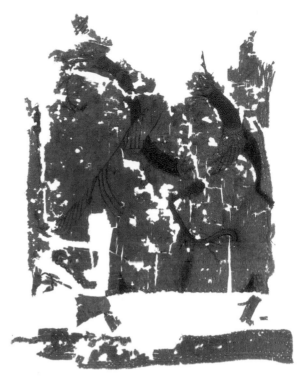

▲ **Fragments of Silk Fabric Uncovered in Xinjiang**

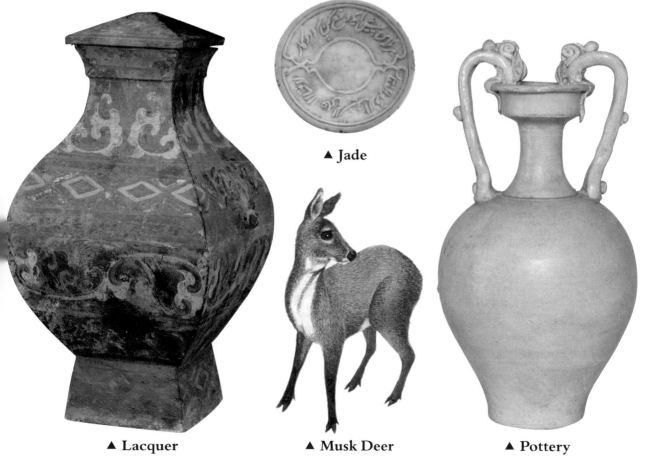

▲ **Lacquer** ▲ **Jade** ▲ **Musk Deer** ▲ **Pottery**

Coming East

A lot of goods also came from the west to China through this route. The bustling trade activities on the Silk Road facilitated the commodities distribution between the East and the West and added to people's lives. To be accurate, the Silk Road was not simply an ancient trade route; rather, it was a link for ancient Chinese culture to get connected with civilizations of India, Egypt, Greece, Mesopotamia and Central Asia. It was an artery for the cultural and technological exchanges between the East and the West.

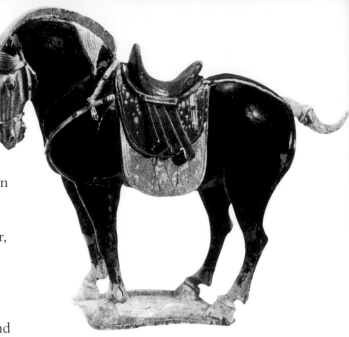

▲ **Horses, One of the Major Imports to the East**

Animals

The "heavenly horses" of Wusun and the "horses that sweat blood" of Dayuan were said to be fine breeding horses from the Western Regions. To get such fine horses Emperor Wudi (156–87 BC) of the Han Dynasty even sent an army to conquer Dayuan. Trade of silk with horses and tea with horses had always been bustling on the Silk Road. In addition, a number of animals and birds were imported from the Western Regions to China: camels as freight vehicle and rhinoceros, lions, elephants, peacocks, parrots and sables as rare treasures for display.

Plants

Pomegranate was one of the important fruits brought back from the West via the Silk Road and so were grapes. When Zhang Qian opened up the route to the Western Regions, wine, a special product of the west, came in great numbers to China and was well-liked. Alfalfa, an excellent feed for horses, was also introduced to China about the same time and was widely grown in the Han Dynasty. Also introduced from the Western Regions were crops such as walnuts, sesame, broad beans, cucumbers, garlic, carrots and spinach.

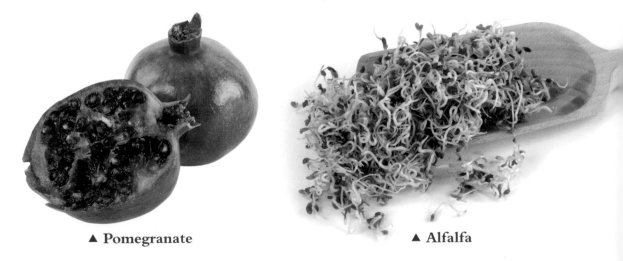

▲ **Pomegranate**　　　　　　　▲ **Alfalfa**

Handicrafts

Products from the Western Regions, such as colored glaze, treasured stones, coral, amber, hawksbill, rhinoceros horns, ivory, celestime, and fur and woolen products were also important commodities transported via the Silk Road to China. Among them azure stones, first produced by the Roman Empire, were shipped to China as luxurious ornaments before the Han Dynasty. By the Northern Wei period (386–557) people in Luoyang started to produce azure stones on their own, and azure stones have been widly used in China ever since.

▲ **Scented Powder Box**

Spices

Principal spices coming from the Western Regions include: mastic from Persian Gulf, benzoin from Iran, storax from Rome, myrrh and aloe from Somalia, rosemary from North Africa, sandalwood from East Africa, and pepper from India. These spices were mostly processed into resins and balsams that were sold all over the world.

▲ **Pepper**

▲ **Colored Glaze Bowl**

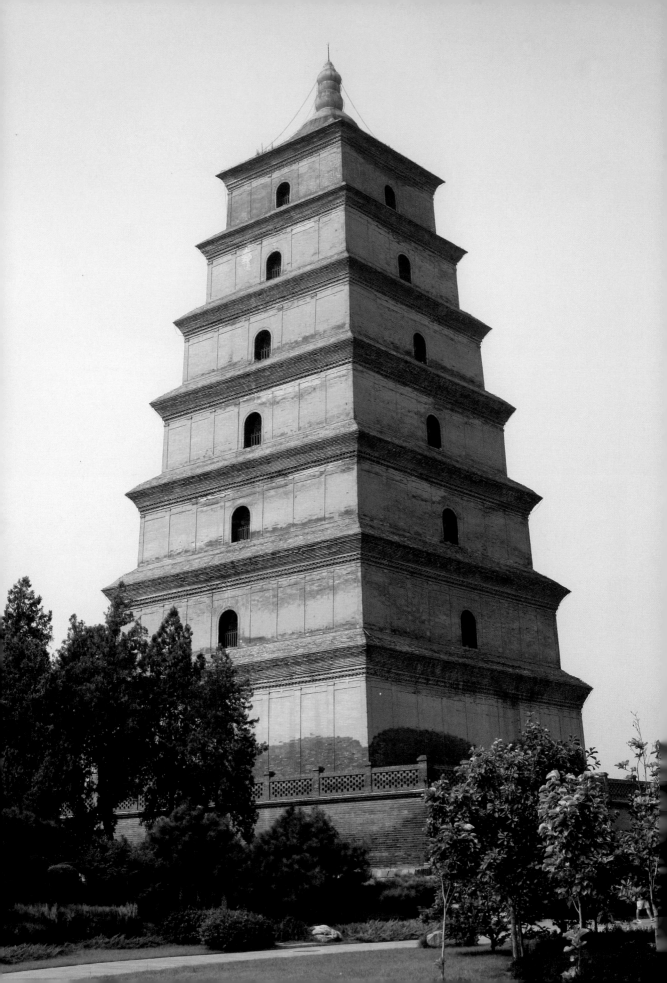

BUDDHISM IN CHINA

Eastern Han Dynasty

Originating in ancient India around 1,500 BC, founded by Gautama, Buddhism was introduced to China at the beginning of the Gregorian calendar, about the time of the Eastern Han Dynasty. For two thousand years since its inception in China, Buddhism gradually transformed and came to constitute an indispensable part of the traditional Chinese culture.

Wei, Jin, Northern and Southern Dynasties witnessed the most important period of Buddhist development in China. A great number of Buddhist scriptures were translated into Chinese. People of all classes came to believe Buddhism, and Buddhist temples and monasteries were built everywhere. Some world renowned Buddhist cave projects, such as the statues and mural paintings in Dunhuang, Yungang and Longmen, were under construction at this time.

Buddhism was revitalized and further developed during the Sui Dynasty. Emperor Wendi (541–604) of the Sui ordered to build a monastery on each of the Five Sacred Mountains and restore the Buddhist statues and monasteries that were destroyed during

◄ Dayan Pagoda (Great Goose Pagoda) in Da Ci'en Temple (Temple of Great Goodwill)

The pagoda was constructed upon the request of Xuanzang to house the scriptures and Buddhist statues he brought back.

the Northern Zhou period (557–581) when Buddism had been a taboo. The development of Buddhism reached its peak in the Tang Dynasty. A great number of eminent Buddhist monks and scholars made their appearances and local-grown Buddhist sects emerged one after another, which included the Pure Land, the Chan and the Lü. In the Northern Song Dynasty the imperial court was protective of Buddhism and the religious exchanges between Chinese and Indian monks were frequent. In the Southern Song Dynasty, even when the majority of the territory was lost and the imperial court had to retreat to the lower reaches of the Yangtze River, the imperial court still maintained a protective approach toward Buddhism. Consequently, Buddhism managed to maintain its prosperity. In the Yuan Dynasty, although the Mongols advocated the Lamaism, they adopted a protective approach toward Buddhism in the Han occupied territory. Zhu Yuanzhang (1328–1398), the first emperor of the Ming Dynasty, who had been a monk, personally preached Buddhist doctrines and followed a monk's practice when he came to power. By so doing he hoped to cement the newly-built Ming power, taking advantage of Buddhist doctrines. In the Qing Dynasty emperors were all avid believer of the Lamaism and tried to restrict Buddhist activities in the Han people-occupied territory. Despite the restrictions Buddhism was prevalent among the Han people.

Development of Chinese Buddhism

During the Wei, Jin, Northern and Southern Dynasties, China was in a state of disunity and plagued with warfare. Religion as a result had great appeal to the Chinese suffering from hardship and insecurity. People's need for salvation, coupled with the support of the ruling class, brought about the first boom of Buddhism in China. Buddhist scriptures were translated systematically of which Kumarajiva, the most eminent monk, made the greatest contributions.

By the Sui and Tang dynasties Buddhism, which had existed in China for four or five centuries, entered a period of great prosperity thanks to the support of the powerful and unified empire. Other locally grown branches and sects emerged one after another. Some of them were further developed by later generations and left profound influence on people's lives. These branches and sects include the Pure Land, the Chan and the Lü. Xuanzang, eminent monk of the Tang Dynasty, traveled fifty thousand *li* alone to India to pursue Buddism, a story that was frequently told in China's Buddhist history. When he came back to China over ten years later, he devoted the rest of his life to translating Buddhist scriptures.

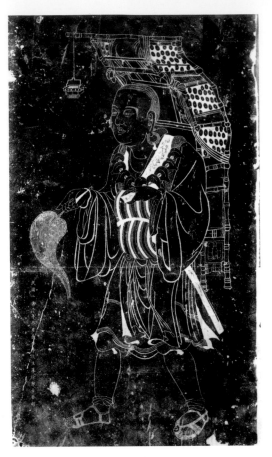

▲ Xuanzang

Ranking among the three finest translators of Buddhist works with Kumarajiva and Paramartha, Xuanzang, a Tang Dynasty monk known to later generations as Tang Seng, translated Buddhist works such as *Mahāprajñāpāramitā Sūtra* and the *Heart Sutra. Journey to the West (Xiyou Ji)*, one of the four Chinese Classics, was based on the story of Xuanzang travelling to India in pursuit of Buddhism.

This portrait of Xuanzang is a rubbing from a stone tablet in Xingjiao Temple, Xi'an, a Buddhist Pagoda where Xuanzang's relics are kept. The stone tablet, 1.76 meters high and 0.67 meter wide, has the inscription of "Xuanzang Dharma Master" on its top right corner.

◄ White Horse Temple in Luoyang

In the seventh year of Yongping (64), Emperor Mingdi of the Han sent an envoy to the Western Regions to inquire about Buddhist religion. In 67 the envoy brought back two eminent Indian monks named Kasyapa Matanga and Dharmaraksa. Legend has it that the classics and Buddha's statues were carried to China by white horses. The two monks began to translate some of the Buddhist scriptures. Meanwhile, the first Buddhist temple, which was named the White Horse Temple, was built, signifying the official introduction of Buddhism in China although Buddhism had appeared much earlier than this.

Manifestations of the Localized Buddhism

Chan

Chan or Zen is said to have been introduced to China by an Indian monk named Bodhidharma in the Southern Dynasties (420–589), but it was Hui Neng (638–713), the Sixth Patriarch of the Chinese Han sect of Buddhism, whose doctrine left a far-reaching influence on later generations. He stressed self-realization. He believed that Buddha-nature is in all men so that all can become Buddhas, and that people can attain sudden enlightenment and immediate awakening of the mind, and in this sense everyone can become Buddha. Hui Neng did not believe in written doctrines but held that this realization of the Buddha-mind can take place at any moment and in any way, whether awake or asleep. This was an unprecedented drastic change in the history of Chinese Buddhism and it testified to the localizing of Buddhism in China. Hui Neng's Chan doctrines had a profound influence on the Chinese literati-officials, who henceforth started to pursue Buddha-mind in their works of literature, poetry and painting.

Guanyin: the Changed Image of Avolokitesvara in China

The most typical manifestation of how Buddhism adapted to local Chinese culture is the changed image of Avolokitesvara, known as the Goddess of Mercy. When Buddhism was first introduced to China, Avolokitesvara was a virile man. As the doctrines of this god spread among local people, Avolokitesvara began to take on a feminine form at the Northern and Southern Dynasties. This made her a localized figure. This female Bodhisattva, in addition to helping people who were suffering from misery, started to assume the usual role of a goddess granting people offsprings they wanted, an invention of the Chinese people.

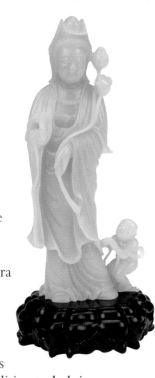

▲ Portrait of _Songzi Guanyin_

The image of _songzi guanyin_ (Guanyin Granting Offsprings) has been the most popular of the many Bodhisattva statues among the general Chinese populace.

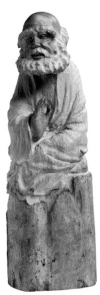

▶ Bodhidharma (_Damo_)
Bodhidharma, originally from South India, was said to have arrived in China in the first half of the sixth century. He taught Chan Buddhism in China and is regarded as the founding father of Chinese Chan Buddhism which was derived from Mahayana Buddhism.

▶ The Sixth Patriarch Cutting a Bamboo
This picture portrays the story of the Sixth Patriarch cutting a bamboo. With an old tree in the background, the Sixth Patriarch, holding a knife, was cutting a dead bamboo. Huineng was illiterate, but that did not prevent him from becoming a Chan Master. He believed that "the subtlety of Buddhism has nothing to do with literature." Through physical labor like cutting a bamboo, he could find his true self, free from the obstacles of literature and scriptures. Like the cloud in the sky and water in the bottle, as long as you understand the nature of things, you could hear the sound from Heaven even while hitting the bamboo.

BUDDHIST ART

Wei, Jin, Northern and Southern Dynasties

In this period, China witnessed the most frequent dynastic changes in its history. The long period of political turmoil and civil war ended with the integration of the north and south, including different ethnicities. Han Chinese culture began to spread to the south and there was an influx of Western culture to China, too. Buddhism, which was introduced in the Eastern and Western Han dynasties, also flourished during this time and became an important part of Chinese ideological field. Buddhist arts also prospered, with Buddhist cave art as an example. Cave temples were built for meditation as a way of repelling worldly desires. The construction, murals and sculptures inside the caves are visual demonstration of such artistry. In China, Dunhuang, Yungang, Longmen and Kizil Caves form the most important pantheon of Buddhist arts.

▼ A Caisson Ceiling Painted with Flying Apsaras (*Feitian Zaojing*)

Zaojing is a frequently used art form in the decorations of Dunhuang Caves. *Zaojing* borrows the techniques of ceiling decorations in traditional Chinese architecture, i.e. decorative patterns painted on the concave surfaces of round, square and polygon. Traditional wooden structures are susceptible to fire and therefore water plants such as lotus flowers are the motifs for painting. Initially *zaojing* of Mogao Grottoes took lotus flowers as a predominant theme. Gradually other patterns started to emerge, such as flying apsaras, dragon and phoenix and canopy, and they were applied in many places. Among these, flying apsaras are most representative of Dunhuang's artistic images. They are goddesses who dance, sing, and scatter blossoms to serve Siddhartha Gautama. These apsaras are always floating images in the air of beautiful women who sing and dance.

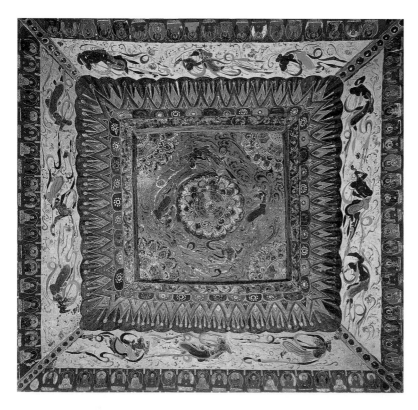

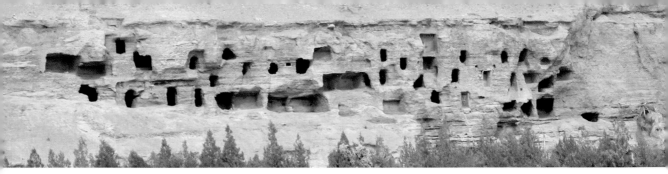

▲ **Exterior of Dunhuang Caves**

Timeless Dunhuang

Around 366, a monk named Le Zun started to carve the Dunhuang Mogao Grottoes, which marked the beginning of the popular art form of caves sculpture. Dunhuang Mogao Grottoes are located on the cliff of Mingsha Mountain (Singing Sand Mountain), northeast of Dunhuang City, Gansu Province. Its cave art is a mix of architecture, sculpture and painting, forming a timeless treasure house of art.

▼ Jataka of the Nine-Colored Deer (section)

Dunhuang murals, which refer to the paintings on every surface of the corridors, the four walls and the ceilings, are an important part of Dunhuang's cave art. The murals that have existed to this day cover an area of about 50,000 square meters in all. These paintings include portraits of Buddha, Bodhisattva and Buddhist followers, stories about Buddhism (including stories about Buddha's life, the Jataka tales, stories about hetupratyaya and transformation), mythology and depictions of secular lives at that time. Some of the elongated pictures, shaped like a scroll, depict vividly and exquisitely stories about Buddhism. The Jataka of the nine-colored deer is among the early masterpieces of Dunhuang caves.

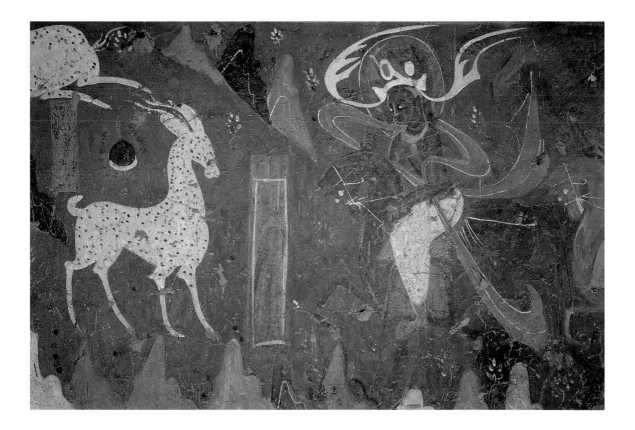

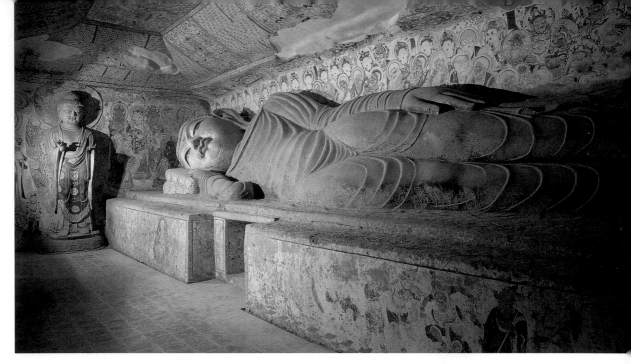

▲ Giant Buddha

Statues of Buddha, usually tall and empowering, are a contrast to the humbleness of mortal beings. Buddhist followers and benefactors across the country try at all cost to build colossal statues of Buddha to express their humility and piety. The statues are scattered all across China, such as Leshan Buddha at Sichuan Province and Lushena Buddha at Longmen. Finely executed Buddha statutes are also found in Dunhuang. For example, Cave 96 houses a stone-bodied clay-stuccoed sculpture of Maitreya, which is thirty-five meters tall; Cave 148 is home to a colossal lying Buddha. The Buddha above is from Cave 158, the Buddha in Nirvana, which is fifteen meters long and lying on a bed over a meter above the ground. The Buddha, eyes half closed, appears serene, content and smiling. The features on his face, the bun on his head and the creases in his clothes are all softly and beautifully executed.

▶ A Painted Bodhisattva Statue

This painted clay statue is a Bodhisattva created in the peak of the Tang Dynasty. Located in Cave 45, it is an exquisitely executed statue: she gracefully stands there, her head tipping slightly to the side, her body the shape of an S, her eyes half-closed, her lips wearing a smile—an elegant figure with a benevolent and charming countenance. Totally different from an Indian Bodhisattva, the features that have turned feminine clearly give statues like this its Chinese characteristics. Painted statues in High Tang testified to the highest artistic achievements among those in the Mogao Grottoes. These statues of female Bodhisattva, plump and beautifully dressed, were apparently meant to satisfy the secular aesthetic taste of the Tang people.

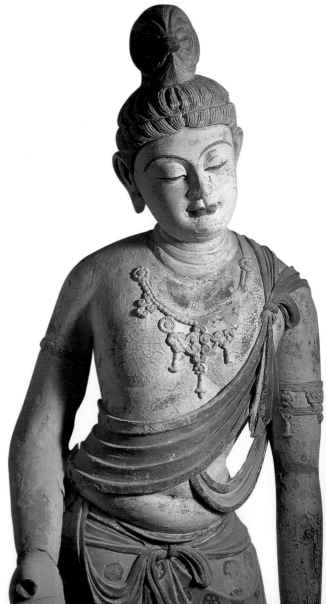

Longmen Grottoes

Longmen Grottoes, whose construction first started around 494, took about 400 years to complete. Of which, Fengxian Temple, started in the Tang Dynasty, houses the biggest group of nine statues, including a Buddha, two disciples, two Bodhisattvas, two heavenly kings, and two warriors. Among them the main statue—Virocana Buddha is 17.14 meters tall and has a 4 meters tall head and 1.9 meters long ears, with its trunk round and plum, an imposing and powerful presence.

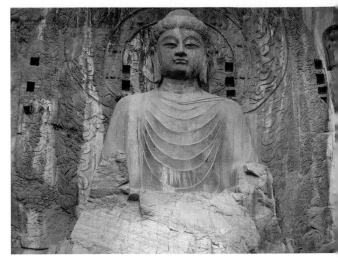

▲ **The Big Vairocana of Longmen Grottoes**

Yungang Grottoes

The carvings in Yungang Grottoes, located in Datong, Shanxi Province, were first started in 460. Most of the caves in Yungang Grottoes were completed around 494. They display an unprecedented fusion of styles of Buddhist statuary reflecting the secularization and localization of Buddhist art in China. Take Caves 9 and 10 for example: the entrances of both caves have octagonal columns that are carved with numerous Buddhas; inside the caves, the niches for Buddhist statues, whose tops and lintels reflect the style of Han-Dynasty architecture, are considered to have combined the structure of Central and Western Asian architecture and traditional Han-styled architecture.

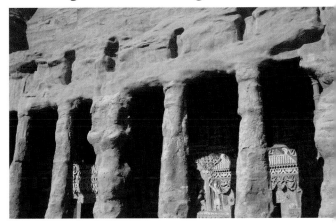

▲ **Yungang Grottoes**

Kizil Caves

Probably first carved at the end of the third century in Xinjiang, China, Kizil Caves are also known as Caves of a Thousand Buddhas. It was one of the first Buddhist cave complexes located at the farthest west of China's territory. As a large cave-cluster, it is a demonstration of the tremendous achievements of Kucha, one of the significant states in the western part of the ancient China, with achievements in religion, culture, art and customs over a period of 500 years from the end of the third century to the end of the eighth century.

◄ **The Mural in Cave 175 of Kizil Caves**

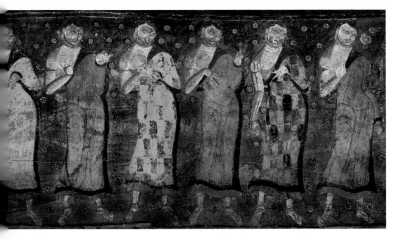

WISDOM DISPLAYED IN WATER SYSTEM PROJECTS

Sui Dynasty

Water system projects are closely related to rivers and directly influence human activities. With the focus shift of the nation's agricultural economy, the construction of water system projects has gradually moved from the Yellow River Basin to the Huai River, Yangtze River and Pearl River (Zhujiang River) basins.

Preconditioned by the geographical location and the predominant agricultural economy, the Chinese developed a unique system of water works, which included taming the water and preventing flood, mostly the lower reaches of the Yellow River; irrigation for farm land; water system for transportation, which included a water transport system that linked rivers such as Hai River, Yellow River, Huai River, Yangtze River and Pearl River.

As early as the Xia Dynasty the Chinese acquired primitive way of irrigating the fields. By the Western Zhou Dynasty a preliminary form of water system was developed that could reserve and channel water, irrigate fields and discharge water when it overflowed. By the time of the Spring and Autumn and the Warring States periods a number of large scale irrigation system works, such as Dujiangyan and Zhengguoqu, had been completed. These irrigation system works facilitated the agricultural development in China's Central Plains and the western part of Sichuan. Irrigation works for farm fields were available across the Yellow River plain

▲ **The Ancient Grand Canal**

and the northwestern part of China in the Sui and Tang dynasties. Tongjiqu and Yongjiqu completed under Emperor Yangdi (569–618) of the Sui Dynasty facilitated the south-north bound water transportation, while the Grand Canal linking Bejing and Hangzhou became the main artery of south-north bound transportation.

These water system works indicated that ancient Chinese had clear understanding of the characteristics of the rivers they were working with and made renovations based on their understanding of the laws of nature. These works were manifestations of the Chinese philosophy of the harmony between man and nature. Many ancient water system works have been in use for thousands of years, which have improved the natural environment of a region. For instance, the two-thousand-year-old Dujiangyan has created the affluent *tianfu zhiguo*, or the Land of Abundant, on the Chengdu Plain.

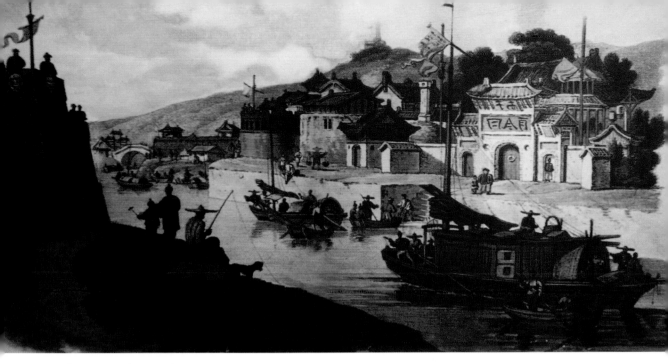

▲ The Grand Canal

The Grand Canal Linking Beijing to Hangzhou

China is the first country to dig canals in the world. First constructed in the Spring and Autumn Period, the Grand Canal kept expanding thanks to the effort of subsequent generations. The Sui and Yuan dynasties witnessed the largest scale reconstruction. The canal was over 2,000 kilometers long,

linking together five river systems of the Hai River, the Yellow River, the Huai River, the Yangtze River and the Qiantang River. It ran through a vast expanse that included today's provinces of Hebei, Shandong, Henan, Anhui, Jiangsu and Zhejiang, constituting a north-south bound water transportation artery in the feudal dynasties of Chinese history. This Grand Canal is more than two thousand years old and is still in use today.

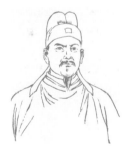

▶ Guo Shoujing (1231–1316)

A famous scientist in the Yuan Dynasty. The maintenance and safeguard of the Grand Canal proved just as huge and complex as its construction. Guo Shoujing, who took charge of the reconstruction project in the Yuan Dynasty, made two great contributions to the Grand Canal: first, he set straight some winding parts of the canal, thus shortening the distance for navigation; second, he initiated a number of projects to clear the silts and channel new sources of water into the canal so that the water system ran more smoothly.

◀ Map of the Grand Canal in the Sui Dynasty

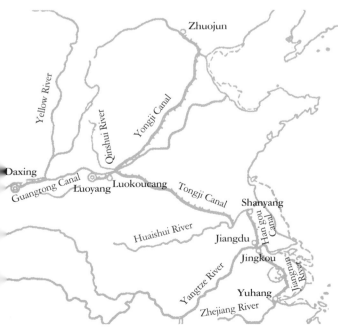

▲ Dujiangyan Irrigation System

Dujiangyan Irrigation System

Located in Sichuan Province, Dujiangyan was an enormous irrigation system that channeled water without having to use a dam. It is one of the oldest large scale irrigation systems in the world that has been kept to this day. In the third century BC while a governor of Shu (Sichuan Province today), Li Bing made thorough investigations about the Min River and decided to start an irrigation system at the top of Chengdu Plain where the principal stream of the Min River ran down the mountain. The construction proved difficult but was eventually completed as what we know now Dujiangyan. More than two thousand years later Dujiangyan is still playing an important role in the irrigation of that area, which testifies to the appropriate selection of its geographical location and the appropriateness of its design. The whole project was so scientifically planned and coordinated that Dujiangyan was able to channel water for irrigation, tame the flood by using an opening in the mountain instead of building a dam to divert the water flow. These functions complemented each other and people are still enjoying the wisdom of their ancestors even to this day.

▶ Lugou Bridge in Beijing

A granite bridge with a series of arches. It has a history of more than 800 years. A test was once done to see how much weight it could endure. Amazingly, a flatbed vehicle carrying 429 tons of cargo rolled over the bridge, and the bridge still stood. Lugou Bridge is also well-known for the stone lions on both sides. Big or small, male or female, they are executed with vivid features and no two lions look the same. Some people say, "The number of lions on the Lugou Bridge is too great to keep track of." There are about four or five hundred lions engraved on the columns of the bridge. Indeed too many to count.

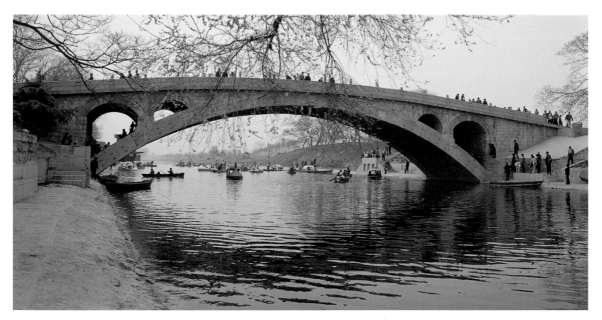

▲ Zhaozhou Bridge in Shijiazhuang, Hebei Province

It is the world's oldest surviving stone bridge that has been preserved intact to this day. The bridge, which is more than 1,400 years old thanks to the incredible work of its designers, spans over the river with only one main arch, a stable design that allows maximum volume of water and minimizes the impact of flood water toward the bridge. The two smaller arches on each shoulder of the big arch not only help alleviate the weight of the bridge but also increase the volume of water under the bridge. They also make the structure of the bridge appear light and elegant.

Bridges in Ancient China

China is a big country with many rivers crisscrossing in its vast territory. This has made China a country with many bridges.

People are often amazed at how many bridges were built in ancient China, their varieties, the exquisite executions and the beautiful designs. Craftsmen utilized their experience and wisdom to build bridge after bridge that was designed to accommodate the natural environment and cultural atmosphere. Some of the bridges were made close to perfection in terms of the application of mechanics, irrigation engineering and architectural aesthetics. These ancient structures have remained an important attraction to modern day China.

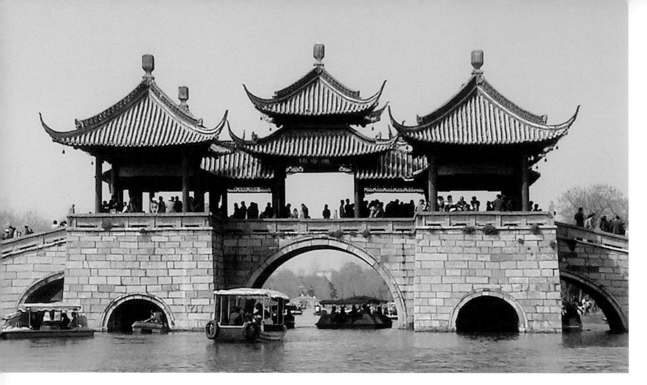

▲ Wuting Bridge in Yangzhou, Jiangsu Province

First built in the eighteenth century, this stone arch bridge has a unique design to match the beauty of the Shouxi Lake (Slender West Lake). The plane of the bridge looks like the Chinese character 工 (*gong*). There are fifteen arches under the bridge and twelve piers of different sizes to support the bridge. On the bridge are five exquisite and elegant pavilions with glazed roofing tiles. One more thing worthy of note is the piers: they are made of slabs of blue stones whose crevices were filled with cement and juice of sticky rice.

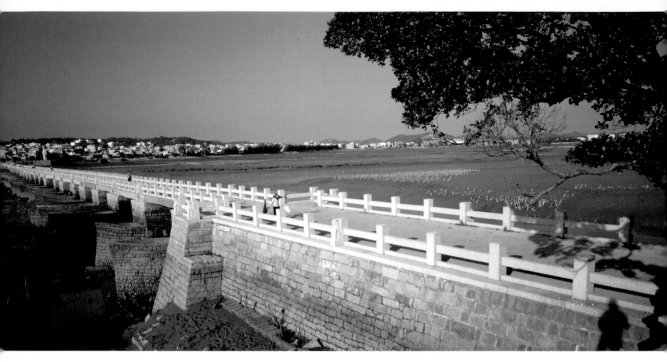

▼ Chengyang Bridge in Sanjiang, Guangxi Zhuang Autonomous Region

Chengyang Bridge has five piers, with each pier crowned with a five-storied pavilion. Each pavilion is joined by a long corridor. In the rainy season in Guangxi, people can walk or take a rest on the bridge without being bothered by the rain. This bridge is thus given another name, "A Bridge Free of Rain and Wind." In addition to the beautiful sight and the shelter they offer, these pavilions play a more important mechanical role: they were fixed on the end of the beam to balance off the weight placed on the beam.

▲ Luoyang Bridge in Quanzhou, Fujian Province

One of the first harbor bridges that were built with stone piers and stone beams in China. First built in 1041 as a floating bridge, it was reconstructed into a stone bridge in 1053. The bridge is best known for its boat-shaped piers with pointed heads, which were in fact an application of what we now call the theory of fluid mechanics. When the tides of the river and the sea rose they helped to facilitate the flow of the torrent. More interestingly, records show that stones were first laid under water to form the lower part of the piers, and in the meantime oysters were cultivated along the stone piers: the oysters were said to act as a living glue to cement the stone slabs to form a solid bulk.

AN OPEN EMPIRE

Tang Dynasty

I n 618 Li Yuan, Emperor Gaozu (566–635), established the Tang Dynasty, one of the most brilliant dynasties in Chinese history. At the height of the Tang Dynasty in the seventh century, its jurisdiction reached as far as the desert area of Central Asia. Li Shimin, Emperor Taizong (599–649), the second emperor of the Tang Dynasty and an outstanding strategist and statesman, brought about *zhenguan zhizhi*, a period well-known in history for its economic prosperity and political stability. The Chinese feudal society reached its peak at this time.

The Tang Dynasty started to decline after the insurrection waged by An Lushan and Shi Siming and came to an end in 907 when Zhu Wen (852–912) usurped the throne. The whole dynasty lasted 289 years and saw a succession of 19 emperors.

A unified country with a well-developed economy, China was a vibrant international power during the Tang Dynasty. With its strong national power and an army well-trained for fighting, the country earned the political prestige of a superpower and was admired and respected by its peripheral countries. Tang also attracted students, businessmen and admirers from all over the world, Asia in particular, because of its sophisticated civilization and trade activities. In the Tang Dynasty China experienced a period that was most open and tolerant to alien cultures.

Tang had friendly exchanges with Arab

▲ Portrait of Emperor Taizong

Chieftains of ethnic minorities in the northwest part of China addressed Emperor Taizong as Celestial Kaghan (*Tian Kehan*) as a sign of respect for him and of their submission to the Tang Dynasty. Kehan is a title equivalent to Emperor.

countries, too. Foreign things such as emerald and pepper made their appearance in China. So did religions such as Islam. Also via the Arab region, Chinese inventions, such as paper making and fabric weaving, were disseminated to Western Asia and Europe. Neighboring countries in eastern Asia, including Silla, Bohai Nation and Japan, were greatly influenced by the Tang Empire in terms of political system and culture. Meanwhile, products, religion, culture and art from the Western Regions enriched the lives of the Tang people.

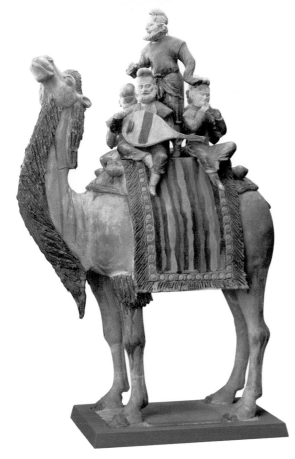

▲ A Pottery Showing Three Musicians on a Camel's Back

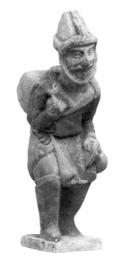

▲ A Pottery Traveler Figurine from Tazi (the Arabs)

▲ A Painted Figure of a Black Dancer

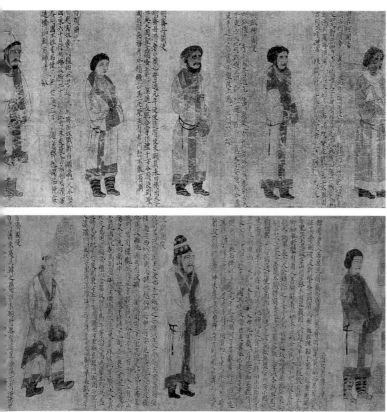

▼ Officials in Different Positions

The Tang Dynasty witnessed the heyday of Chinese interaction with the rest of the world in the entire course of Chinese feudal history. At that time Chang'an, the Tang capital, attracted diplomats, as well as students, artisans, monks from Asian and African countries, making it a cosmopolitan city. To better facilitate foreign exchanges with other countries, the Tang government set up a department called *Honglu* responsible for the reception of guests. Over seventy countries had close contacts with the Tang. A large number of foreigners came to study, do business and travel in China. Some of them even stayed and worked for the Tang imperial court. As a big, unified empire, the Tang had strong national power, abundance of resources and the Tang people enjoyed high standard of living and civilization. All these were manifestations of China as a powerful country surpassing all others in Asia and also standing among the most advanced countries in the world. The Tang rulers and ordinary people had little prejudice and rejection toward alien people and cultures that were flooding in. Instead, they warmly welcomed the people and absorbed their cultures. As a result, alien cultural customs were visible in every aspect of the Tang life, which in turn indicated Tang's confidence in its culture.

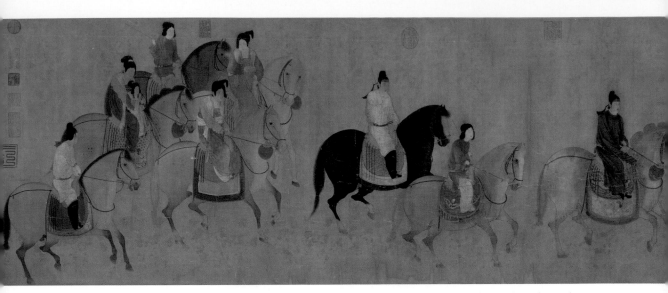

▲ *Spring Outing of Noble Ladies*, by Zhang Xuan of the Tang Dynasty

This painting depicted the sister of Emperor Xuanzong's (685–762) beloved concubine Yang Guifei (719–756) on horseback for a spring outing. Details of their outfits, hair styles and the lavish scale of the event reveal the degree of extravagant life style in the Tang court.

Fashion

Clothes and costumes from the Western Regions and countries such as India and Persia had once been the fashion of the upper class. They were characterized by felt and leather hats, knee-length coats, narrow sleeves, crew neck, turndown collar or open neck on button down jacket, leather belts, narrow openings at the bottoms of pants and leather boots.

▶ A Beautiful Woman Dressed in *Hu*-Styled Clothes

Hu-styled clothes is a term encompassing all styles of clothes other than that of the Han Chinese people living in the Central Plains region, whose attire was looser with wide sleeves, etc.

Music and Dance

Music from peripheral countries also left profound influence on Tang's local music. Different styles of music from other regions, which were known as the "new music," found their way into the existent forms of Tang music and became widely popular among the Tang people. Some important traditional Chinese musical instruments, including *pipa*, *yaogu* and *konghou* are actually imports from other regions. A number of dance forms from countries such as India were hotly pursued by the Tang nobles.

▶ *Playing the Pipa from behind the Player's Back*
This painting from Dunhuang's Mogao Grottoes depicts a Tang performer dancing while he is playing the *pipa*.

▼ **Playing Polo**
A game first introduced to China from the western regions, polo was popular with the Tang emperors and nobles. Many aristocratic women also liked to play the game of polo.

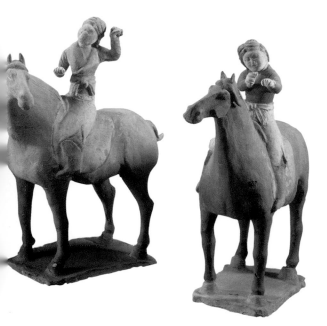

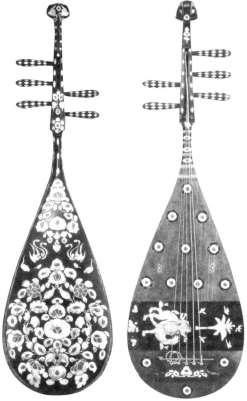

▲ *Pipa of the Tang Dynasty*

Tang Poetry

Tang literature flourished to an unprecedented level in Chinese history. Its poetry in particular peaked among all classical poetry in China. Tang poems covered a wide range of topics and reflected a variety of schools. Some described the fields and gardens and landscape, while others sang the beauty of frontier scenery; some portrayed love stories in the imperial court, while others depicted travelers on the road. Among the most well-known Tang Dynasty poets are Wang Wei (Poet Buddha, 701?–761), Li Bai (Poet Immortal, 701–762), and Du Fu (Poet Sage, 712–770).

▶ *Snow over the River*, by Wang Wei
Wang Wei's poems are credited as having the feel of the paintings, and his paintings the feel of the poetry. This painting, *Snow over the River*, is said to be painted by Wang Wei.

Bird-Chirping Hollow

Wang Wei

Sweet laurel blooms fall unenjoyed;
Vague hills dissolve into night void.
The moonrise startles birds to sing;
Their twitters fill the dale with spring.

(*Translation by Xu Yuanchong*)

▶ Painting by Fu Baoshi based on Li Bai's Poem

In *Bring in the Wine*, Li Bai lamented that his talent was not put to use. The poem exudes pride and enthusiasm. The painting here was by Fu Baoshi (1904–1965), who painted it based on Li Bai's poem *Bring in the Wine*.

On facing page
Painting by Fu Baoshi based on Du Fu's Poem

In *On the Height*, the first half of the poem depicted scenery, while the second half expressed the poet's emotions. This painting by Fu Baoshi thoroughly revealed the poem's artistic conception.

On the Height

Du Fu

The wind so swift, the sky so wide, apes wail and cry;
Water so clear and beach so white, birds wheel and fly.
The boundless forest sheds its leaves shower by shower;
The endless river rolls its waves hour after hour.
A thousand miles from home. I'm grieved at autumn's plight;
Ill now and then for years, alone I'm on this height.
Living in times so hard, at frosted hair I pine;
Cast down by poverty, I have to give up wine.

(Translation by Xu Yuanchong)

Bring in the Wine (Excerpt)

Li Bai

See how the Yellow River's waters move out of heaven.
Entering the ocean, never to return.
See how lovely locks in bright mirrors in high chambers,
Though silken-black at morning, have changed by night to snow.
... Oh, let a man of spirit venture where he pleases
And never tip his golden cup empty toward the moon!
Since heaven gave the talent, let it be employed!
Spin a thousand pieces of silver, all of them come back!

URBAN CIVILIZATION

Tang Dynasty

About 4,000 years ago (the end of the primitive period) China started to build *cheng* (city walls). *Shi* usually refers to marketplaces inside the city walls. Cities in the early Qin Dynasty were mainly political and military centers. Around the Eastern Zhou Dynasty various states tried to annex each other's territories. Larger states generally had their capital cities developed into big cities. In the Spring and Autumn Period, Linzi of the Qi State was a city that covered an area of sixty square kilometers with eleven gates. Neatly-organized trunk roads and plumbing system works were found across the city. Also available were mills specializing in casting of iron, bronze and coin, and making bone ware. All this testified to the degree of sophistication of industry and trade of that city.

As territories expanded from the dynasties of Qin, Han to Tang, population multiplied as well. The number of cities rose and the size of cities grew accordingly. Chang'an, capital of both powerful Han and Tang empires, had been a perfect example of comprehensive cosmopolitan cities in ancient China. Having nine marketplaces, Chang'an was a city with the greatest consumption capability. With the advent of the Grand Canal linking Beijing and Hangzhou and as the economic center kept moving southward, many affluent commercial cities sprang up along the Grand Canal in the lower reaches of Yangtze River.

From the Song Dynasty to the Ming and Qing, as commodity economy continued to grow, economic factors had taken the place of political and military factors to become the key element sustaining the civilized development of a city. The function of a city grew more diversified and industry was more clearly defined and more specialized. Examples of these include Suzhou and Hangzhou, cities with specific industries, and Quanzhou, a port of trade.

▼ **The Tang Hibiscus Garden after its Restoration**

Chongxuan Gate

Xuanwu Gate

Linde Hall

Daming Palace

Hanyuan Hall

West Inner Garden · Danfeng Gate

Xuanwu Gate

Palace City

Kaiyuan Gate

Chentian Gate

Tonghua Gate

The Imperial Palace

Zhuque Gate

Xingqing Palace

Quanguang Gate

Chunming Gate

West Market

East Market

Zhuque Street

Yanping Gate

Yanxing Gate

Da Ci'en Si

Qujiang Pool

Anhua Gate Mingde Gate Qixia Gate

▲ Floor Plan of the City of Chang'an

Chang'an of the Tang Dynasty was one of the largest cities in the world. The entire city was composed of the outer city, the palace city and the imperial city, covering an area of eighty-three square kilometers. It was booming with trades of all kinds and at its peak, the population reached close to 500,000. Chang'an, a rectangular on a floor plan, was laid out on a central axis with symmetrical arrangement. Streets crisscrossing the city divided it into 110 wards. Besides them were commercial and industrial districts called the "East Market" and "West Market," as well as a man-made garden named Hibiscus Garden. Encircling Chang'an were four streams and canals: Longshou, Qingming, Yong'an and Caoqu. They introduced, at the east, west and south directions, water from branches of the Wei River to the city for consumption and environment.

Cities with Singular Function

Center of Handicrafts Industry

They refer to cities that developed as a result of the handicrafts industry in the locality. For example, Songjiang in Shanghai, Suzhou and Hangzhou were known for their textile industry; Jingdezhen, Yixing in Jiangsu Province, Boshan in Shandong Province for the manufacturing of porcelain; Zigong in Sichuan Province for its salt making industry.

Domestic Commercial Centers

These type of cities were usually developed because of their favorable geographical locations for transportation. In ancient times a great many commodities were transported through rivers and canals, so these cities were usually located along navigable natural water systems, by canals or where two rivers met. For example, such cities were located along the Grand Canal as Yangzhou, Huaiyang, Linqing in Shandong Province, Cangzhou in Hebei Province and Tianjin, as well as cities located where two rivers met, such as Yibin in Sichuan Province of the Yangtze River and Min River, Chongqing of the Yangtze River and Jialing River, and Hankou in Hubei Province of the Yangtze River and Han River.

Centers of Overseas Trade

There were cities that had been harbors for

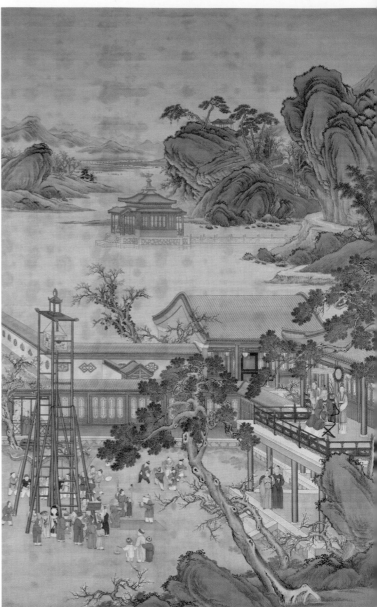

▲ Temple Fair

Festival celebrations and temple fairs were an important part of urban life in ancient China. In most places across the country a City God Temple Fair was held annually. What was important was not the worshipping of City Gods but that it was an occasion where people from all walks of life gathered and engaged in all sorts of fun activities, such as selling things, fortune telling and giving performances. Business was particularly brisk during the Spring Festival and the Lantern Festival, when women, who were not supposed to show up on the street, were allowed to eat, gamble and have fun in the street.

overseas trade. They were usually favorably located where big rivers merge into the sea. They usually had natural rivers and harbors and occupied a vast expanse of inland river delta. Take Guangzhou of Guangdong Province for example, it was located at the river mouth of Pearl River and adjacent to oceans. It has been a overseas trade center since the Han and Tang dynasties. It harbored a large concentration of foreign merchants, known as *fan chang*. There were also churches built by the foreigners. The earliest mosques in China were located in Guangzhou and Quanzhou.

Defensive Forts

A great number of forts were built for defense in the Ming Dynasty given the unstable political situations both at home and abroad. They included "nine heavily militarized towns of the northern frontier" along the Great Wall, Xuanhua, Youyu and Shanhaiguan Pass; and defensive forts along the coastline in such places as Weihaiwei, Jinshanwei and Zhenhaiwei.

▲ *Jiaozi*—**the First Paper Money in the World**

As circulation of commodities multiplied, the world's earliest currency made its appearance in Chengdu of Sichuan Province in the early days of the Northern Song Dynasty. It was called *jiaozi*, used for payment of goods. In 1105, the authorties of the Song Dynasty renamed it as *qianyin*, and it started to circulate in most parts of the country.

▼ **Shanhaiguan Pass**

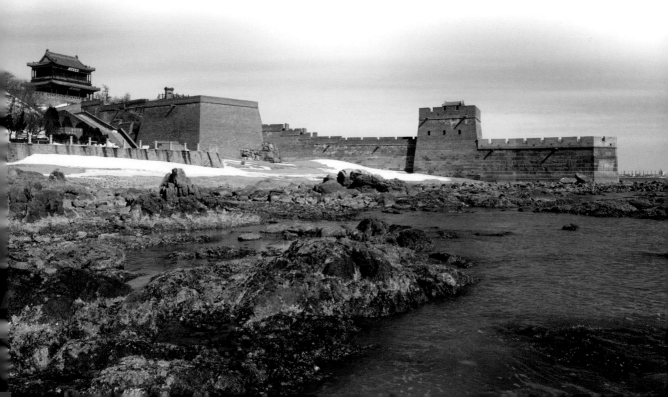

Urban Life and Customs

Unlike the agricultural economy in the country, cities were developed either because of their political importance or because of their advanced handicraft industry or trade activities. People concentrated in cities, where the division of labor and a variety of services the city provided constituted a dynamic picture of urban life. The initial stage of city life was for the most part reflections of the life style of the aristocrat. Ordinary people were only supplementary to the aristocrat. As urban population grew, the situation changed. By the Song Dynasty urban commercial activities started to take a turn toward the ordinary people, and urban life also began to assume the characteristics of the ordinary people. Services geared toward the masses, began to flourish.

Entertainment in the City

Prior to the Tang Dynasty, rigid rules were applied regarding the zoning of an urban space. Forms of entertainment in the imperial court were inaccessible to the ordinary people. By the Northern Song Dynasty, the class barrier came down and high-end entertainment began to appear among the ordinary people. It was evidenced by the emergence of a venue for popular entertainment— *washe*. A *washe* was divided into different halls designed for different performances. They were called *goulan*. By the Southern Song Dynasty in the capital Lin'an there were numerous *washe*, where a variety of stage performances were presented and a whole set of other services provided: department stores, medicine stores, fortune telling, gambling, food, barber shops and paintings.

▼ **A Picture of Street Vendors**
This picture describes small retailers selling along the street, capturing the bustling urban commercial atmosphere.

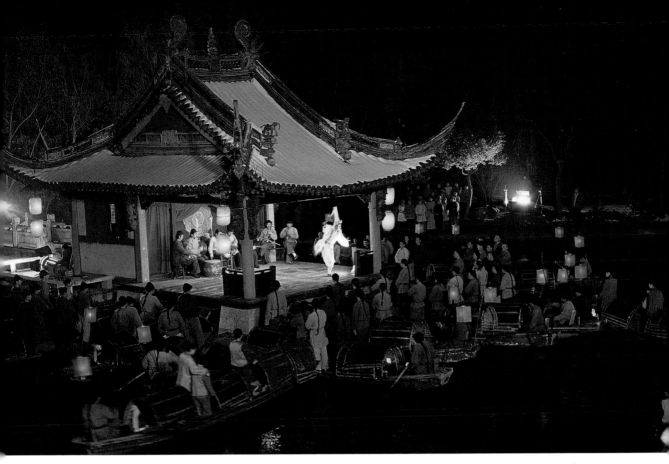

▲ **A Restored Ancient Theatrical Stage**

Means of Transportation in the City

There were a variety of transportation vehicles in ancient Chinese cities but primarily they included sedan chairs, horse or ox-drawn carriages, horses and camels.

大轎
高連頂六尺
濶三尺
進三尺五寸

▲ **A Sedan Chair**

◀ **A Gig**

CHINESE PAINTING AND CALLIGRAPHY

Song Dynasty

Chinese painting, generally called *danqing* (literally red and blue), primarily includes scroll paintings that are painted on silk or paper and later mounted. They are painted with paint brushes, water-color and paint that are unique to China. They follow the forms of artistic expression and rules that had developed generation after generation. Chinese painting and calligraphy are known for the integration of calligraphy, painting and inscription. Painting, calligraphy and seal cutting complement each other. As far as ways of expression are concerned, Chinese painting falls into the following categories: water-color, *zhongcai* (heavy coloring), *gongbi* (meticulous), *xieyi* (freehand style), and *baimiao* (plain drawing). In terms of motifs, Chinese painting can be divided into genres of figures, landscapes, and flowers and birds.

Historically, painting of figures appeared earlier than that of landscapes and flowers-and-birds but the technique matured gradually from the Han to the Wei, Jin, Northern and Southern Dynasties. Well-known figure paintings include *Nimph of the Luo River* by Gu Kaizhi (c. 345–409, Eastern Jin), *Wenyuan Tu* by Han Huang (723–787, Tang Dynasty), *The Night Revels of Han Xizai* by Gu Hongzhong (the Five Dynasties and later Tang), and *The Portrait of Vimaiakirti* by Li Gonglin (1049–1106, Northern Song Dynasty).

By the Sui and Tang dynasties paintings of landscapes, flowers, birds and animals came to be regarded as individual branches, with representative painters such as Zhan Ziqian, known for his natural colored landscape style, Li Sixun (651–716), known for his decoratively colored landscape style, and Wang Wei, known for his water-color style. During the Five Dynasties period and the two Song periods different branches emerged one after another. As time went by, water color painting became prevalent. Painters emerged one after another, such as Jing Hao, Guan Tong, Li Cheng (919–967), Dong Yuan (?–c. 962), Ju Ran and Fan Kuan representing the ink landscape as well as Wang Ximeng (1096–?), Zhao Boju (?–c. 1173) and Zhao Boxiao the blue-and-green landscape.

It wasn't until the Tang Dynasty that flower-and-bird paintings became an independent branch. Paintings of saddles and horses fall into the category of flower-and-bird paintings and reached a very high order of artistic achievements. Examples include *Night-Shining White* by Han Gan, *Five Oxen* by Han Huang and *Half an Ox* allegedly by Dai Song.

Literati painting began developing in the Song Dynasty and saw its heyday in the Yuan Dynasty with a more and more freehand style. It kept developing in the Ming and Qing dynasties, becoming increasingly skillful in expressing the painter's spiritual world. The artistic expression of Chinese

painting is the manifestation of the unique way in which the Chinese people understand nature and society.

The Silk Scroll Entitled *Scenes along the River during the Qingming Festival*

This painting by the Northern Song artist Zhang Zeduan is unrivalled in the history of Chinese art. It is now kept at the Palace Museum in Beijing. *Scenes along the River during the Qingming Festival*, 25.5 cm high and 525 cm long, depicted over 550 people engaged in different activities. The picture, a portrayal of the bustling scene at the Qingming Festival in Bianjing, is a long scroll of the urban lifestyle of the Northern Song Dynasty.

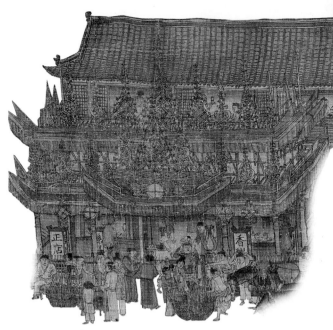

▲ Pubs and Restaurants

Pubs and restaurants of all sizes were scattered all over the city. Big, high-end restaurants had large façade with colored flags and lights hanging outside. Banners signifying the sale of alcohol were flying and the interiors were finely decorated. An abundance of food was served, and the restaurant was full of customers.

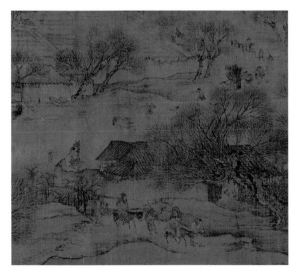

▲ The Beginning Section—the Outskirts of Bianjing

Two porters were driving five donkeys to the city carrying bags of charcoal. A willow grove was visible. On the road was a sedan chair with a woman sitting inside; the top of the sedan chair was decorated with poplar and willow twigs and other flowers; following the sedan chair, people, some riding a horse, some carrying a load, were returning to Bianjing from their trip of tending to the tombs of the departed.

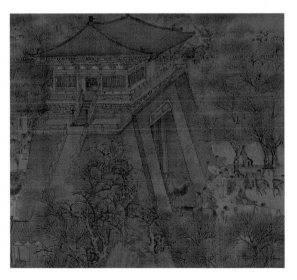

▲ The End Section—the Hustle and Bustle of an Urban Street

In the middle was a tall gate tower. On its two sides were lined rows of houses, including teahouses, restaurants, pubs, the butcher's, temples and administrative offices. The stores were selling silk and satin, jewelry and spices, incense and paper for burning at the temple. In addition, there was a drug store, a clinic, and a vehicle repair shop. People of all professions gathered here, creating an incessant flow.

Figure Painting

In painting figures, the Chinese artists do not seek exact truthfulness in term of every physical detail but strive for the truthfulness of the spiritual subtlety of a character by skillfully using the brush and ink. The doctrine of "less is more" is what makes the figures in Chinese painting distinctive. The painting here by Liang Kai, *Immortal in Splashed Ink*, utilized only a few strokes to bring on paper a character that is vivid and true to life. It is one of the more representative works of Chinese figure painting.

Landscape Painting

Landscape painting is a major branch of Chinese painting that the Chinese love the most. What dominates a landscape painting is natural scenery such as mountains and rivers. Even if there are people in the painting, they are so tiny that they are sometimes completely blended in the voluminous mountains, rivers and forests. This expression of man and nature testifies to the Chinese philosophy of "the unity of man and nature": man is to live harmoniously with the nature. It reflects the Chinese ideal of living a poetic life in the mountains and rivers.

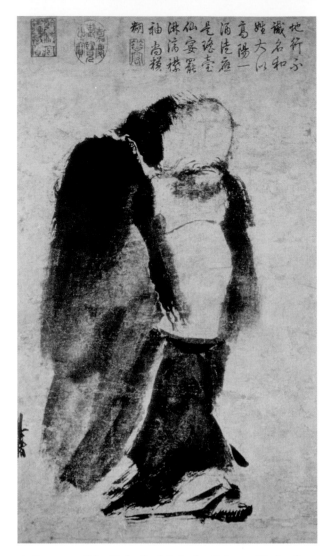

▲ *Immortal in Splashed Ink*, **by Liang Kai of the Song Dynasty**
This is the earliest splash-ink freehand brushwork that can be found in Chinese history. It is now kept in the Palace Museum in Taibei. This form of painting is called "hanging scroll."

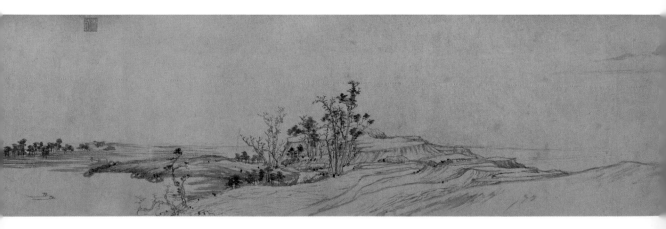

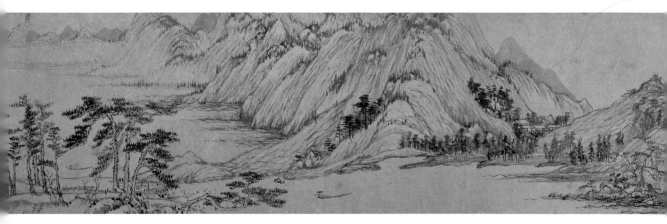

Flower-and-Bird Painting

Chinese painters of birds and flowers do not paint just anything. Frequently appearing in the paintings are pine trees, bamboos, plum blossoms, lotus flowers, orchids, chrysanthemums, peonies, and cranes. Some of them are symbols of auspiciousness, wealth and honor, such as peonies, but more often painters use plants and birds that are traditionally symbols of good spirits, or known for their noble character. For instance, a pine tree is a symbol of perseverance, a bamboo a symbol of modesty, a lotus flower a symbol of purity. When painting the flowers and birds, the painters are in fact trying to express their wish of possessing the same spirit or quality or to use the painting as a self-encouragement.

▲ *A Colorful Parrot*, by Emperor Huizong (1082–1135) of the Northern Song Dynasty

Emperor Huizong, who was the eighth emperor of the Song Dynasty, liked painting and calligraphy very much. This painting, painted on a piece of silk, demonstrates meticulous and powerful brushwork and strong colors. It is kept in the Museum of Fine Arts, Boston, USA.

▼ *Dwelling in the Fuchun Mountains* (section), by Huang Gongwang (1269–1354) of the Yuan Dynasty

This was painted with the Fuchun River as its backdrop. It is one of the representative works of ancient Chinese landscape painting. The painting, split in two parts, has been kept in Zhejiang Provincial Museum and the Palace Museum in Taibei. This form of rectangular painting is called "long scroll."

The Art of Chinese Calligraphy

Calligraphy, often considered *meishu* (or fine arts) in China, is an art form that utilizes Chinese characters as a vehicle to communicate the spiritual world of the artist. The artist works with the lines and strokes of a character within its defined structure to make it look like a painting. Calligraphy as a work of art conveys the moral integrity, character, emotional, aesthetic feelings and culture of the artist. It transcends high abstract lines into a world of art. Wang Xizhi (321–379), the most well-known calligrapher in ancient China, is referred to as the "Sage of Calligraphy."

Antithetical Couplets

Antithetical couplets is one of the traditional forms of Chinese poetry. The first line and the second line have identical number of words and the same syntactical structure, and the content is antithetical.

▼ *Preface to the Poems Composed at the Orchid Pavilion*, **by Wang Xizhi of the Eastern Jin Dynasty**
It is known as "the best of running hand calligraphy in the world" and the most renowned calligraphy work in ancient China.

▲ **Couplet by Master Hong Yi (1880–1942)**
The first line: Abstinence is the key to the ultimate awakening; the second line: Buddha is the wisdom light to all beings.

Fan-Shaped Painting

To paint on fan-shaped surfaces is called *shanmian*. Depending on the different types of fans, there are curved shapes from folding fans and round shapes from flat fans.

▶ **Calligraphy by Yang Meizi**
This was by Yang Meizi (1162–1232) of the Song Dynasty. The work is now kept at the Metropolitan Museum of Art in New York, USA.

▲ **Calligraphy by Shen Yinmo**
This fan-shaped work was by Shen Yinmo (1883–1971), a well-known Shanghai-style calligrapher.

◀ *Night Outing under the Candlelight* by **Ma Lin**
Ma Lin is a painter active in the mid-thirteenth century. It is now kept in the Palace Museum in Taibei.

The Art of Seal Carving

Seal carving is also called *zhuanke*. It has a history of more than two thousand years. In addition to the daily use of a seal that is dipped in the red ink paste to make a stamp on paper, seals are also used in painting for inscribing its title. Inscription in a painting has grown to be a unique art form in China. In ancient times seals were made of materials such as copper, silver, gold, jade and azure stones, but later other materials were also used, such as teeth, horn, wood and crystal. Since the Yuan Dynasty stone seals have been very popular.

Four Treasures of the Study

The writing brush, ink stick, paper and *yan* (inkslab) are the traditional implements and materials for writing and painting. They are considered indispensable in a scholar's study. They are usually called the "four treasures of the study."

Writing Brush

An implement for writing, which generally refers to a brush made with animal hair. The earliest writing brush dates back to over two thousand years ago. There are a

◄▼ An Ink Paste Box
(with a cover)
Also called an ink paste stand, or an ink paste pool. The ink paste is stored in such a box, usually made of ceramics.

good variety of writing brushes available in China. They are usually made with fine craftsmanship of animal hair such as goats, wild rabbits and yellow weasels, and the best writing brushes are made in places including Hunan, Zhejiang and Jiangxi.

▲ Brush Pot

A container where a writing brush is kept when not in use. It is usually made of such materials as ceramics, jade, bamboo, wood and lacquered wood.

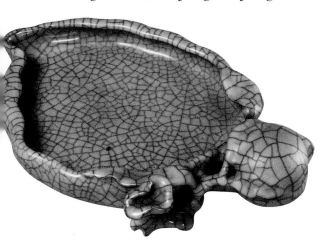

▲ Brushwash

A basin-like container where the brush is washed after being used. It is usually bowl-shaped but sometimes also shaped like a flower petal or a tower.

▼ Brush Stand

A stand where brushes are set to rest while in use.

◀ Writing Brush

To judge the quality of an ink brush, one has to look at the following four aspects: 1. *jian*—the tip of the brush should be pointed when all the hairs gather together; 2. *qi*—the tip of the brush should be levelled when the brush gets pressed after soaking off and the hairs should look neat; 3. *yuan*—the hairs of the brush should look round and full, shaping like a cone; *jian*—the hairs of the brush should be supple.

Ink Stick

An ink stick that ancient Chinese used was hand-made from pine soot. It was initially kneaded with hands and later made with a mould when the mould became available. The ink stick was hard, so water was added to dissolve the ink for people to paint or write with. The most renowned ink was *huimo*, or Hui ink stick, which was made in ancient Huizhou.

▶ Hui Ink Stick

Ancient Hui ink sticks/slabs were primarily made in three counties: Shexian (today's Shexian, Anhui Province), Xiuning (today's Xiuning, Anhui Province), Wuyuan (today's Wuyuan, Jiangxi Province). The ingredients and techniques used for making Hui ink sticks/slabs are quite sophisticated. Hui ink sticks/slabs are beautifully shaped in rectangle, round as well as other shapes. They are light; the ink looks clear and smells fragrant when they are rubbed. They are as hard as jade but make no noise when being rubbed.

▲ Paper Weight

Also called "book weight," for keeping loose paper in place or keeping the book open.

Paper

The paper making technology became available in China as early as in the Western Han Dynasty. The Sui and Tang dynasties saw the emergence of *xuanzhi*, or rice paper, which was mainly produced in Xuanzhou, Anhui Province. Rice paper had been one of the finest quality papers available to ancient Chinese for writing and painting. The advent of woodblock printing spurred the development of paper industry. The number of places capable of making paper increased, and good quality paper emerged one after another.

▼ Rice Paper

Yan (Inkslab)

Yan, or "inkslab," is a sort of millstone where the water is turned into ink by rubbing an ink stick on its surface. It is also where the left-over ink is kept. The most famous inkslabs are *Duan yan* from Zhaoqing, Guangdong Province, *She yan* from Anhui Province, *Lu yan* from Shandong Province, *Longwei yan* from Jiangxi Province, and *Chengni yan* from Shanxi Province.

▲ **Water Pot**

A container where water is stored for injection on the inkslab to make ink. It is usually a round or square container with a spout. Sometimes it is made in the shape of animals such as a toad and a chicken.

◄ **Inkslabs**

Inkslabs, both functional and decorative, are particularly favored by poets and men of letters. Throughout Chinese history, many calligraphers loved ink sticks/slabs and collected them. They include Liu Gongquan (778–865) of the Tang Dynasty, Ouyang Xiu (1007–1072), Mi Fu (1051–1107), Su Dongpo (1037–1101) of the Song Dynasty, and Zhu Yizun (1629–1709) of the Qing Dynasty, all of whom had written works on the art of inkslabs.

SCIENTIFIC DISCOVERIES AND INVENTIONS

Song Dynasty

China had been in a leading position in scientific and technological inventions from the sixth to the seventeenth centuries. In as early as the Warring States Period the Chinese people made a device for direction named *sinan*, a precursor of compass, with natural magnetic iron. It went through several stages of improvement and was applied in ocean navigation in the Northern Song Dynasty. In 105 a man named Cai Lun looked at previous attempts of papermaking and invented a type of paper that was made from barks, broken fishing nets and rags. This paper of plant fibers was especially good for writing. Around the seventh century the technology of papermaking was spreading to Japan through Korea. The invention of printing was based on China's woodblock printing in the seventh century. In the eleventh century a Chinese man named Bi Sheng (?–c. 1051) invented movable type printing, making another leap forward in printing technology. The world owes the invention of gun powder to ancient Chinese alchemists, inspired by an explosion which occurred while they were trying to heat a mixture of niter, brimstone and charcoal. During the Song Dynasty gun powder found its use in military affairs.

Ancient Chinese people also made outstanding achievements that are known to the world in areas such as astronomy, physics, chemistry, medicine, irrigation and shipbuilding. For instance, the combined inventions of seismography, the knowledge of twenty-four divisions of a solar year in traditional Chinese calendar, and the technology of weaving, have helped to accelerate the course of human civilization.

▶ **Gunpowder**
More than 1,000 years ago, the ancient Chinese invented gunpowder while trying to make pills of immortality. Till the Song Dynasty, gunpowder had been used in military weapons.

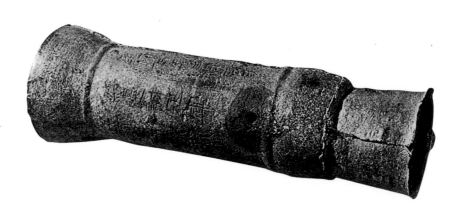

▲ **Paper Produced in the Western Han Dynasty**

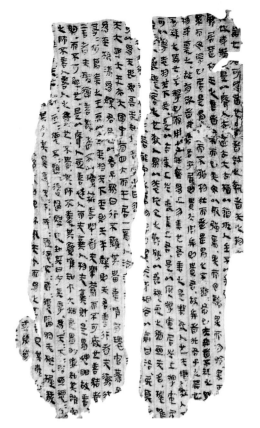

▲ **Silk Books**

Before paper was invented, fine silk was also used as a writing material. Due to its exorbitant price, silk was only affordable to a small number of people, such as members of the royal family and noblemen.

▼ **Cai Lun: the Inventor of Paper**

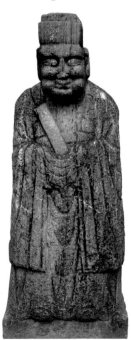

Cai Lun, who lived in the Eastern Han Dynasty, improved the papermaking technology. He put together such things as remnants of hemp and rags of cloth and went through a whole process of soaking, cutting, washing, steaming, cleansing, and pounding to make pulp. He then gathered the pulp and made it into a thin writing sheet. Paper as a writing material became widespread in China and was later introduced to Korea, Japan and the European continent. This invention had profound impact on the diffusion of science and culture around the world.

▲ **Bamboo Slips**

Prior to the invention of paper, bamboo slips were the primary material for writing. A single bamboo slip was called *jian*; when tied together with a rope, the bamboo formed a *ce*. Bamboo slips are not only bulky but also heavy, and inconvenient for reading and transport.

The Paper-Making Process

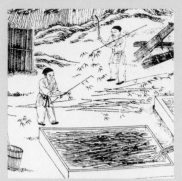

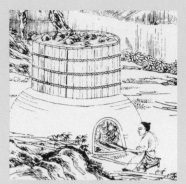

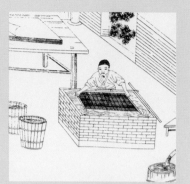

1 The paper makers first have to gather bamboo sticks from the mountains. Then the bamboos are cut into pieces and left soaking for a hundred days before being taken out. The paper makers then proceed to pound and wash the sticks to remove the green shell and the bark so the bamboo becomes softened.

2 They put the softened bamboo material into a wooden barrel filled with lime water and steam. Then they take out the material and have it cleansed in a clear pond. After that, the material is put in a wok filled with lime water and steamed again. The process has to be repeated for a dozen or so days. By repeatedly steaming and cleansing, the bamboo fibers became gradually decomposed.

3 The paper makers then put the thoroughly cooked material in a mortar and pound it so hard that it became something like a batter. Add some water to it and stir, and it becomes a suspension of paper fibers. Then pour the suspension into a sink and sift it with a fine bamboo screen, and a film of paper fiber would be left on the screen.

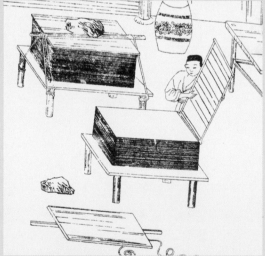

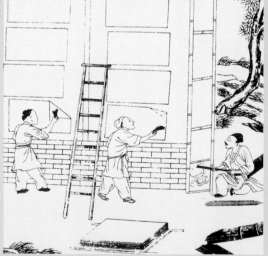

4 Put the bamboo screen with the pulp on a piece of board, the film side facing down. Roll the screen up, leaving the film on the board. Repeat the previous procedures to make several layers of film, one on top of another and press them with heavy objects to remove the moist. The layers of film should become firm and a piece of paper then comes into being.

5 To dry the paper, a fire is set up in the lane lined with brick walls on both sides. Pieces of paper are picked up with copper tweezers and spread onto the surface of the brick wall. The heat coming out of the crevices of the brick wall will dry the paper. Take the paper off when it dries, and the paper should be ready for use.

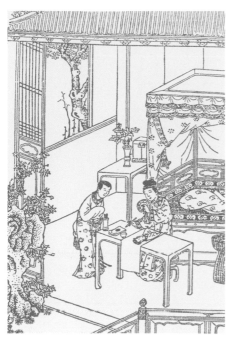

◀ Woodblock Printing

The invention of printing is one of the great contributions the Chinese people made to the world. Prior to the invention, however, books were copied by hand, which was both time and energy consuming. Besides, human errors, such as parts missing by accident or parts copied wrong, happened often.

In the seventh century China invented woodblock printing. The process goes like this: first a piece of paper with the written text is pasted face-down on the woodblock. Then the text is carved in the woodblock. In the meantime remove the parts with no text so the text stands out. Wash to remove the sawdust and the printing block is ready. When printing: brush the ink evenly on the carved woodblock, and spread a piece of paper on the inked block, lightly brush the surface of the paper, and the text or picture is therefore pressed upon the paper. Peel the paper off the block and leave it to dry in the shade making the printing process is complete. When first invented, this technology was mainly used to print Buddhist scriptures and calendars.

▶ The Advancement of Printing Techniques

By the Ming Dynasty the printing technique grew more sophisticated. The quality of printing became increasingly refined due to the emergence of such printing techniques as *banhua*, *taoyin*, *douban* and *gonghua*.

▼ Four Distinctive Methods of Printing in the Ming Dynasty

Method (English)	Method (Chinese Pinyin)	Procedures
Engraved plates	*banhua*	A picture is drawn first, emphasizing the clarity of lines so it is good for engraving. Then have the picture engraved on a wooden plate and the plate is ready for printing.
Embedded printing	*taoyin*	Divide a block into several parts of equal size, depending on the color used, and then print in turn on the same piece of paper.
Assembled block printing	*douban*	Use two or more blocks cut in different sizes and paint them in different colors and then put them together and it is ready for printing.
Blind embossing	*gonghua*	Hard press the woodblock face-down on the paper to leave the print in relief on the paper.

▲ Movable Clay Types

In the eleventh century Bi Sheng of the Northern Song Dynasty invented the movable type printing. He used sticky clay to make Chinese characters. Each character was made an individual type, so it was easy to make different combinations of characters. As a result the clay characters could be used repeatedly and the efficiency of printing was greatly improved.

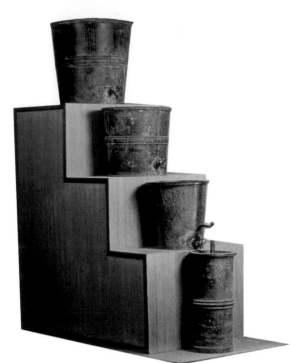

▲ Proving the Value of Pi

Zu Chongzhi (429–500), an ancient Chinese mathematician and astronomer of the Northern and Southern Dynasties, had proved the value of pi (π) as precisely as to the seventh decimal place. This record remained unchallenged until the Arabic mathematician Al-Kashi.

▲ A Clepsydra

A clepsydra is a water clock for showing the time in ancient China. As shown in the picture, the pots are filled with water. By looking at the level of water drops, one can determine the lapse of time. The creation of such a water clock is based on the theory of gradual flow of water. When there is more water in the pot, the water drips more quickly; with less water, it drips more slowly. Therefore, to get an accurate calculation of time, another pot was added at the top so when water in the lower pot was dripping, the water in the upper pot would fill the lower one. In doing so, the water in the lower pot would have a regular flow to the target pot. Clepsydra had been most widely used before the mechanical clock was introduced to China.

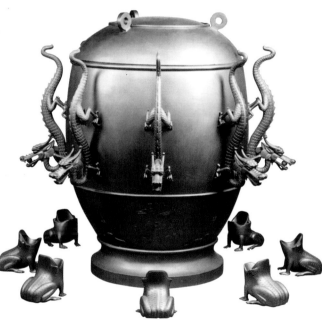

▲ A Model of Seismograph

In 132 Zhang Heng, scientist of the Eastern Han Dynasty, invented a seismograph. It was the first of its kind in the world that was able to predict the location of an earthquake, 1,700 years earlier than the first seismograph was made in Europe.

◄ Compass

The compass is one of the inventions made by the ancient Chinese. As early as the Warring States Period the Chinese used magnet to create a device capable of giving directions. It was called *sinan*, the precursor of compass. Since then, Northern Song Dynasty compasses, which were used in ocean navigation, have played a critical role in the development of ocean transportation and the economic, cultural exchanges between China and other countries.

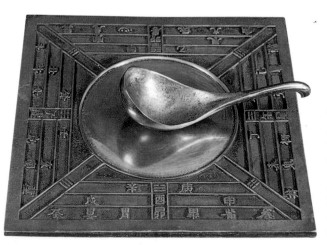

▶ The Twenty-Four Solar Terms

The Twenty-Four Solar Terms, knowledge of time and practices developed in China through observation of the sun's annual motion is a scientific summation of ancient Chinese people's understanding of natural phenomena and natural laws. It is an astrometerological law enacted by the ancient Chinese who tried to facilitate farming activities in appropriate time. This system of calendar was fully established by the Qin and Han dynasties and has been in use up to this day. It was added to the UNESCO world intangible cultural heritage list in 2016.

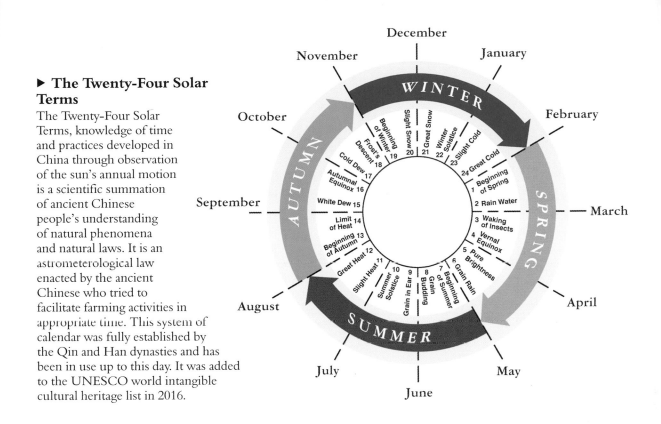

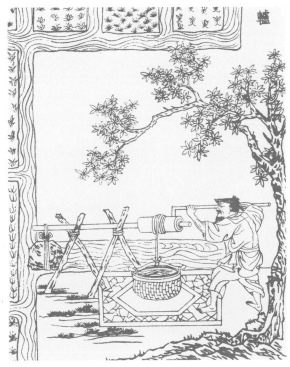

▲ A Wheel Pulley

A wheel pulley was a device for hoisting water from a well. It was created based on the leverage theory. As early as 1,000 years ago, the ancient Chinese invented this device and it was widely employed in irrigating farm land.

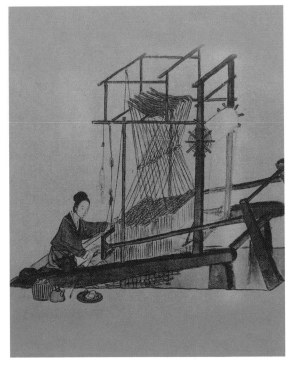

▲ Weaving

This is a weaving machine in ancient China. Ancient Chinese people discovered wheeling early and went on to invent weaving tools such as the spinning wheel, the weaving machine and the jacquard.

WORLD'S FIRST CONTINENTAL VOYAGE

Ming Dynasty

Before the advent of sea expedition in the West, an enormous expedition set out at Liujiagang Harbor in China in 1405. It was commissioned by the Ming emperor and headed by a Chinese national named Zheng He. Being the first large scale intercontinental expedition in the history of the world, Zheng He's voyage testified to the Chinese sophistication in shipbuilding and navigation skills.

Ming's developed skills in shipbuilding can be illustrated by the Bao Shipyard, the first state-owned shipyard established by the Ming administration. It specialized in making battle ships, fleets for the imperial family and the imperial court, as well as errand ships. Most of the ships employed by Zheng He were built by the Bao Shipyard.

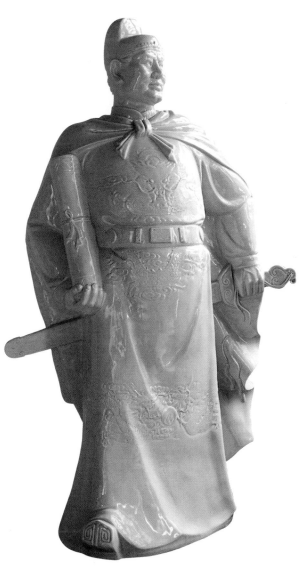

From 1405 to 1433 Zheng He had made a series of seven voyages reaching over thirty countries and regions such as Vietnam, Thailand, Peninsular Malaysia, India, Sri Lanka, Bangladesh, and today's Somalia at the east coast of Africa. The number of ships involved in these expeditions ranged from sixty to 200. Some served as headquarters and others were used for shipping logistics and soldiers. The expedition was equipped with as many as 20,000 people, including sailors, captains, craftsmen, doctors, translators and armed forces. Zheng He traded China's ceramics, silk and iron wares for pearls, treasured stones and spices from Asian and African countries. Tremendous diplomatic achievements were attained during the expeditions. Many countries established diplomatic and trade relations with China after Zheng He's visits. Historical sites and relics of Zheng He's visit can still be found to this day in some Southeast Asian countries.

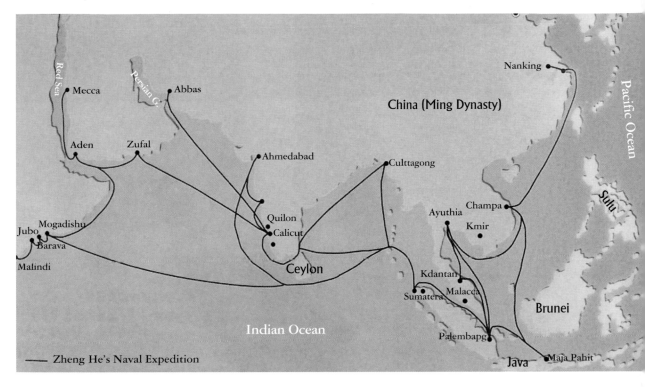

Map labels: Red Sea, Mecca, Persian G., Abbas, Aden, Zufal, Ahmedabad, Culttagong, China (Ming Dynasty), Nanking, Pacific Ocean, Jubo, Mogadishu, Barava, Malindi, Quilon, Calicut, Ceylon, Ayuthia, Kmir, Champa, Sulu, Kdantan, Malacca, Sumatera, Brunei, Palembapg, Indian Ocean, Java, Maja Pahit

—— Zheng He's Naval Expedition

▲ Map of Zheng He's Voyages

Zheng He made a series of seven voyages, the first three of which reached the southwest coast of the Indian peninsular and the rest went as far as the Persian Gulf and Africa.

◄ Zheng He

Zheng He is a great navigator in the Chinese history and a pioneer in the world cultural exchanges. From 1405 to 1433, he was ordered by Zhu Di, Emperor Chengzu of Ming, to sail to the countries and regions west to the South China Sea for 7 times altogether.

▼ A Model of Zheng He's "Ship of Treasure"

The ship by which Zheng He made his expeditions was known as the "Ship of Treasure." The ship was 138 meters long and 56 meters wide, had nine masts and 12 sails, much bigger than the one used by Columbus 87 years later. It was the biggest wooden sailing vessel the world had ever seen and was equipped with the most advanced equipment.

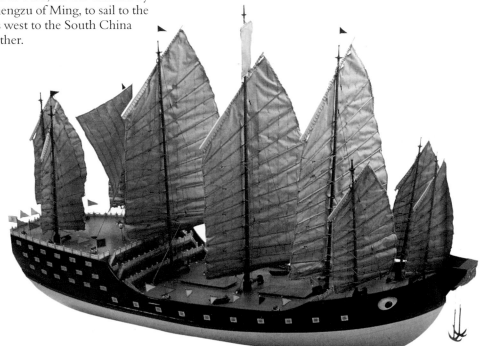

▶ The Significance of Zheng He's Expeditions

Zheng He not only introduced China's pottery, tea and medicine to other countries but also China's advanced farming techniques, culture and arts. This stone figure of a military officer standing at the Grand Palace in Thailand was dressed in a similar outfit to a military officer in the Ming Dynasty.

▼ Zheng He Cast the Bronze Bell

In 1431, before Zheng He's seventh voyage, he cast this bronze bell to pray for safety and placed it in a temple. There are inscriptions on the bell, such as *guotai min'an* (the country flourishes and people live in peace) and *fengtiao yushun* (the weather is favorable).

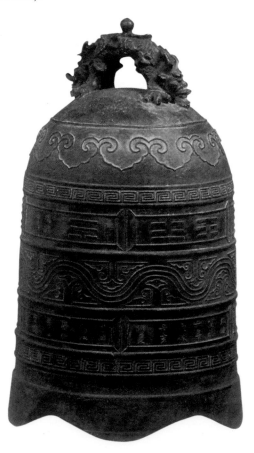

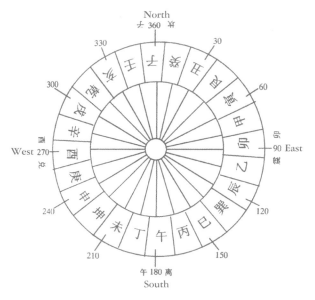

▲ The Diagram of a Compass

Zheng He's ship was equipped with advanced navigation devices such as a navigation map and compass. The compass he used was divided into twenty-four positions that meant to locate forty-eight directions.

THE LIVING SPACE OF THE IMPERIAL FAMILY

Ming and Qing Dynasties

The Forbidden City was home to twenty-four emperors of the Ming and Qing dynasties who had lived and administered national affairs there. It is also the largest surviving ancient architectural complex that still exists in China today. Covering an area of 720,000 square meters and a complex with as many as 9,999.5 rooms, the whole palace is like a rectangular city encircled by a 52-meter wide moat outside the city walls. Three principal halls were built along the central north-south axis and all the buildings on the east and west wings were strictly lined up along the same axis, forming a symmetrical pattern in the east-west direction. This central axis not only runs through the Forbidden City but also extends beyond to the south to Yongding Gate and to the north through the Drum and Bell towers. It virtually runs through the whole city, signaling unequivocal order. The Forbidden City is a wooden structure with glazed yellow tiles on the roof and bluestones and whitestones on the ground. The whole structure is decorated with splendid color paintings in green and gold. The motif of supreme imperial power and unchallenged prestige are implied in every detail of the Forbidden City.

The emperors also made sure that places for relaxation and entertainment be built. The Summer Palace was one such establishment built in the Qing Dynasty on the outskirts of Beijing. Its design integrated the devices and imagery used in the gardens of Jiangnan (lower reaches of the Yangtze River). It is a huge garden built on natural landscape, covering an area of 290 hectares and making it the largest surviving imperial garden in China.

In addition, in Chengde, 230 kilometers away from Bejing, the Mountain Resort was built. It was a designated summer resort where the Qing emperors could stay to avoid the summer heat and carry out administrative work. The Mountain Resort in Chengde is a huge compound that consists of many palaces as well as other buildings designed for administrative purposes and ritual activities. Temples of different architectural styles and the imperial garden blended neatly into the surrounding lakes, pastures and woods. The size, the luxury and grandeur of the imperial palaces and gardens is not only a manifestation of the paramount power of the emperor but also elements that constitute the living space where the emperors executed their power and lived their lives.

▼ **A Turtle**

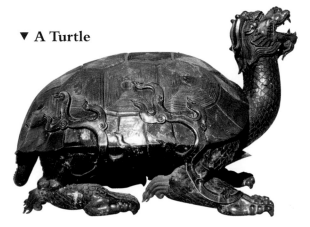

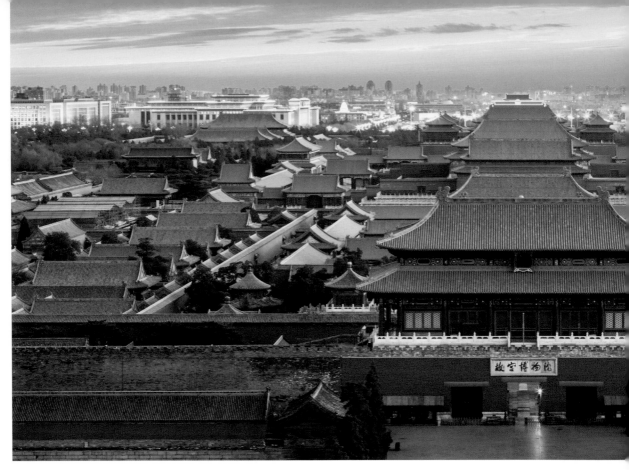

▲ An Aerial View of the Forbidden City

▼ A Scene of the Grand Wedding Ceremony of Emperor Guangxu (1871–1908) at the Taihe Hall (Hall of Supreme Harmony)

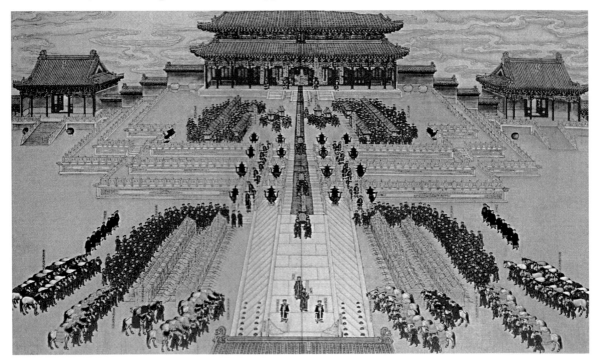

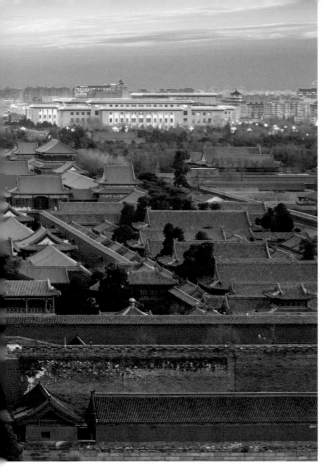

▲ Nails on Wumen Gate (the Meridian Gate)

Nails are a fixture on many of the gates in the Forbidden City. Some are arranged in nine columns of nine nails, totaling eighty-one nails. Number of such mysterious nature can be found everywhere in the palace, a sign of Chinese ancestors' sense of number worship.

▼ Red Walls and Yellow Tiles of the Forbidden City

The Forbidden City is characterized by its red walls and yellow tiles. According to the ancient Chinese theory of the Five Agents, yellow, denoting the Earth and also the center, symbolizes supreme honor and is therefore the color used exclusively by the emperor; red traditionally is a symbol of happiness, contentment and sublimity. Consequently, red and yellow dominate the color schemes of the Forbidden City.

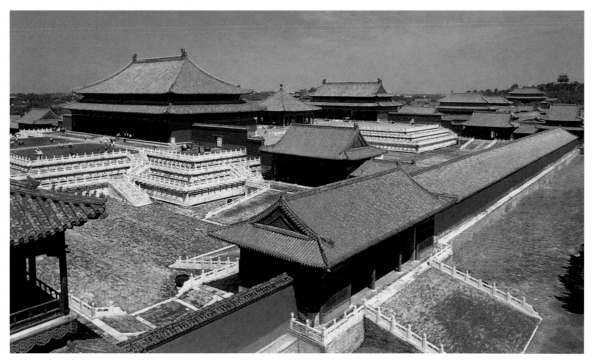

Lucky Animals and Birds

Animals and birds such as turtles and cranes are considered lucky because they are the embodiment of the imperial family's wish for the perpetual solidarity and peace of the country and the prosperity of its people.

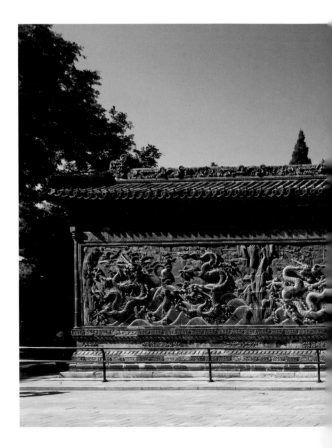

◀ **The Animal Statuettes on the Roof Ridge of the Hall of Supreme Harmony**
Small animal statuettes are often found decorated on the roof ridges of ancient Chinese buildings. The number of statuettes usually ranges anywhere from one to nine in odd numbers. The maximum of nine can be used. The Hall of Supreme Harmony, however, is an exception. Ten statuettes are mounted on the roof ridge, an act testifying to the unrivalled supremacy of the Forbidden City.

◀ **A Crane**

▶ Stone Staircases Engraved with Clouds and Dragons

The dragon has been the most prestigious symbol of auspiciousness in the Chinese culture. The emperor was revered as the "True Dragon and Son of Heaven." Consequently, the imperial palace where the emperor lived was filled with images of dragon. The flight of stairs here was part of the imperial road leading to the Baohe Hall (Hall of Preserving Harmony). It was engraved with nine dragons flying in the clouds, an imposing and dignified presence. The stair is over 16 meters long and three meters wide, making it the biggest stone engraving in the Forbidden City.

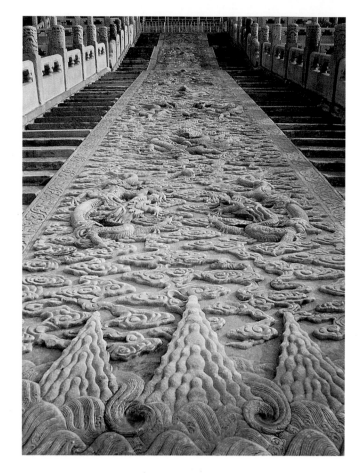

▼ The Nine Dragons Screen

The screen wall is covered with glazed tiles decorated with nine dragons of different colors and bearings.

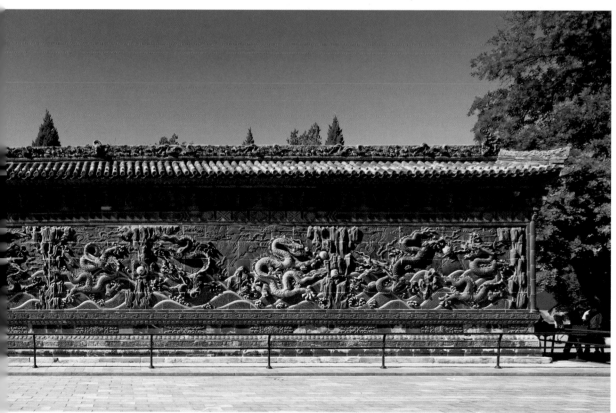

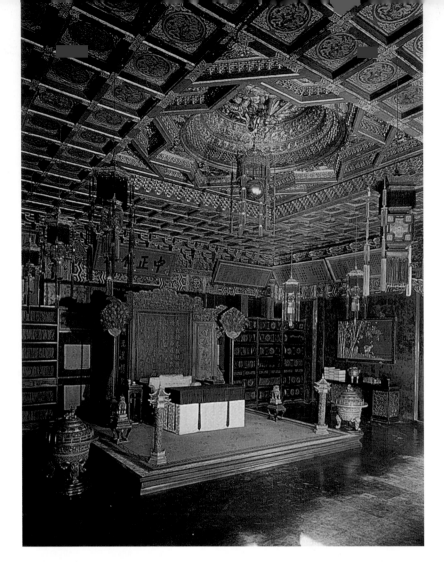

◄ The Yangxin Hall (Hall of Mental Cultivation Proper)
The Hall, with court desk and an imperial throne, serves as a location where the emperor in the Qing Dynasty would meet his ministers and officials as well.

► Temple of Heaven
(A Place of Ritual Ceremony)
It was a place of worship for the imperial family. To pray to Heaven was one of the most important national affairs for the emperors throughout Chinese history. Although it has very few free-standing structures, the Temple of Heaven covers an area that is four times that of the Forbidden City. The Qinian Hall (Hall of Prayer) for Good Harvests, which stands 38 meters high at the center of the Temple of Heaven, is higher than the Hall of Supreme Harmony—the symbol of imperial power. It was the tallest building in ancient Beijing, one that stood closest to Heaven.

◄ The Interior of the Changchun Palace (Palace of Eternal Spring)

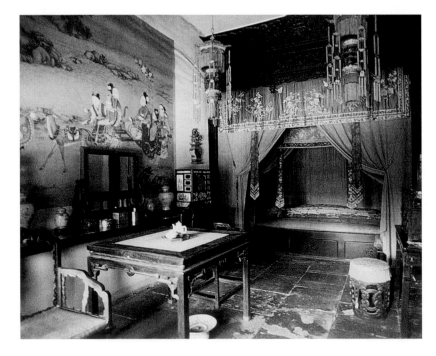

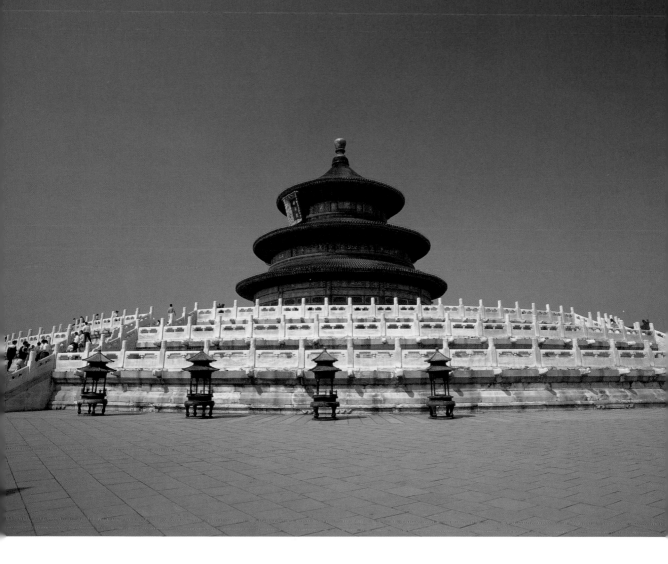

◄ Yonghe Lama Temple, the Eight Outer Temples

(Religious Sanctuaries) Located in the northeastern part of Beijing, Yonghe Lama Temple had been part of Prince Yongzheng's (1678–1735) court before he ascended to the throne and it was also the birthplace of Emperor Qianlong. In 1744 it was converted to a Lama Temple. Its original roof tiles were replaced by yellow ones, elevating the temple's status to that of the Forbidden City. The temple, which was exclusively used by the imperial family, was one of the most prestigious lamaseries in the country.

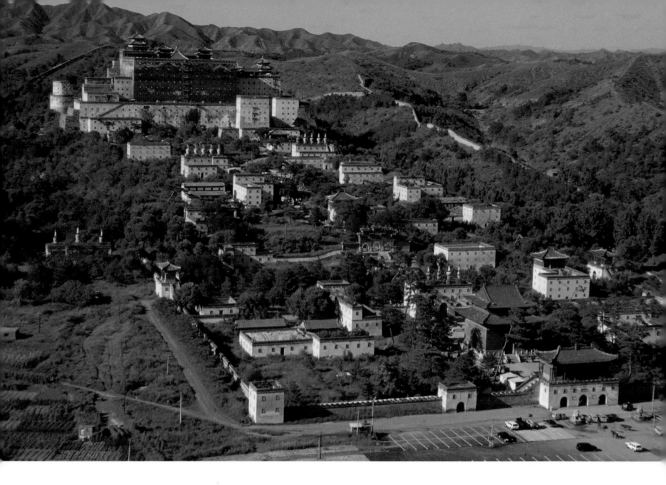

The Mountain Resort in Chengde and the Summer Palace
(Places for Recreational Activities)

The Mountain Resort in Chengde and the Summer Palace are famous temporary dwellings for the imperial family. Unlike the grandeur and solemnity of the Forbidden City, these palaces, overlooking a beautiful landscape, were constructed in the mountains and by the lakes and were perfect destinations for emperors' relaxation. It is interesting to note that the Mountain Resort in Chengde and the Summer Palace, though located respectively in Chengde, Hebei Province and the northwest outskirts of Beijing, were both inspired by the landscape in the lower reaches of the Yangtze River: Kunming Lake and Longevity Hill of the Summer Palace were inspired by the landscape of the West Lake in Hangzhou, and some of the devices and imageries used in the gardens in the

▲ Little Potala Palace
(Religious Sanctuaries)

Outside the wall of Chengde Imperial Summer Villa, the Qing government was commissioned to build twelve temples, which included Puning Temple, Pule Temple and Putuo Zongcheng Temple, making it the biggest imperial temple group. These temples incorporated architectural styles of a variety of ethnic groups such as Tibetan, Mongol, Uighur and Han. These temples, built for aristocrats of ethnic minorities and religious leaders who came to meet the emperor, played a critical role when dealing with issues of ethnic relations.

south were incorporated in the design; the Little Jinshan Complex and Yanyu Pavilion (Pavilion of Mist and Rain) of the Mountain Resort in Chengde were carbon copies of namesakes in Zhenjiang and Jiaxing of Jiangsu Province. It is evident that the imperial family, though living in the north, had a preoccupation with the beautiful landscape of the south.

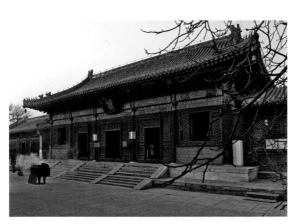

▲ Little Jinshan Complex

Little Jinshan Complex at the Mountain Resort in Chengde was modeled on Jinshan of Zhenjiang, incorporating elements of Jiangnan into the garden of North China.

▼ Pavilion of Mist and Rain

This pavilion at the Mountain Resort in Chengde is a building inspired by the Pavilion of Mist and Rain in Jiaxing.

▲ The Long Corridor in the Summer Palace

UNIQUE RESIDENTIAL BUILDINGS

Ming and Qing Dynasties

Compared to the living space of the imperial family, residential buildings of ordinary folks in ancient China were also varied and colorful.

Due to the limited financial power of an individual and the pressure of social stratification, ancient Chinese residential buildings strived to maintain a status parallel to the owner's social status. The residence of an executive officer is called *fu*; that of an ordinary official is called *zhai*, and that of a commoner *jia*.

Differences in natural environment and humanistic characteristics have cultivated varied styles of residential buildings across China. Take northern and northeastern China for examples, where residences are characterized by four-sided courtyard house. They are designed along a north-south central axis with symmetrical distribution on both sides. In the lower reaches of the Yangtze River, however, residences are usually built along the water systems with white walls and gray tiles—a simple and elegant style, bright yet peaceful. In the Huizhou area, houses are heavily decorated with brick and wood carvings. By the middle and late Ming Dynasty when the economy was strong, people showed an interest in building private gardens. These gardens, big or small, all demonstrated a quality of exquisiteness and elegant grace.

Regardless of their sizes and styles, ancient Chinese residential buildings present

▲ **Illustration of Four-Sided Courtyard House**

A three-color glazed pottery house, excavated at a Tang Dynasty tomb at Zhongbao Villiage, Xi'an, Shaanxi Province in 1959. It was modeled after a long and narrow four-sided courtyard house, in the back of which is an octagonal summerhouse and a piece of rockery.

a multidimensional revelation of Chinese history, religion, culture and customs. They also vividly illustrate the aesthetic achievements of the Chinese people.

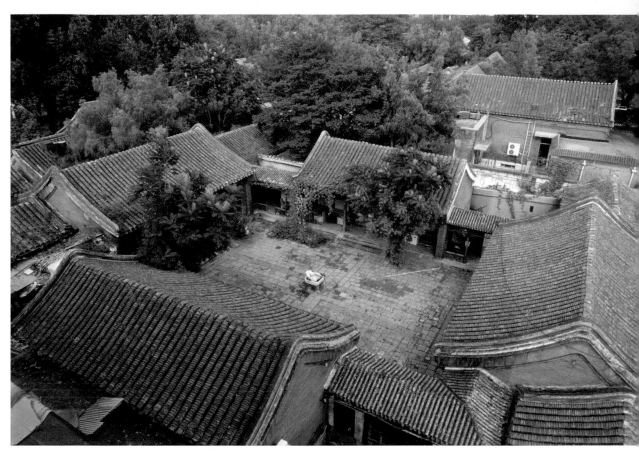

▲ A Four-Sided Courtyard House

▼ A Screen Wall

As one of the important decorations of a courtyard home, a screen wall not only shuts outsiders from seeing the miscellaneous things in the yard, but also prevents people from learning what is going on inside the house. It ensures the privacy of a home. Pictures suggesting good luck are usually painted on the screen, which signifies a good wish and also creates a pleasant visual effect.

Four-Sided Courtyard House in Beijing

Four-sided courtyard houses are a residential architecture that has existed for more than two thousand years. It is a courtyard home designed along a central axis and the rooms are symmetrically distributed. At the center is a main hall; to its left and right are the side rooms. A courtyard home is an enclosed residence isolated from the outside world.

Residences in the Lower Reaches of the Yangtze River

This area usually includes southern parts of Jiangsu Province, Hangzhou, Jiaxing and Huzhou. Little bridges, running waters, and homes constitute a typical scene in the watertowns. Residences are usually built along the water systems with their walls painted white and gray tiles on the roof—a simple and elegant style, bright yet peaceful.

▼ **A Typical Watertown**

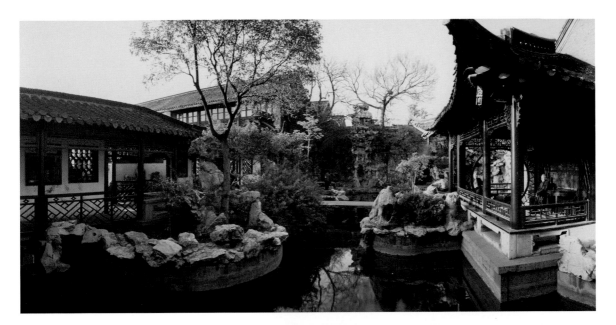

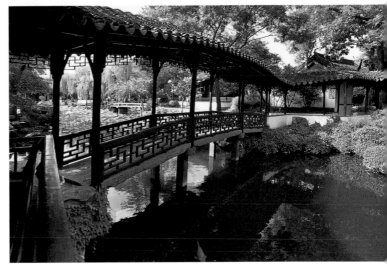

▲ ▲ Private Gardens

Wealthy officials and businessmen had the propensity to include private gardens in their residential quarters. This was particularly true in the middle and late part of the Ming Dynasty. The design of the gardens strove to be exquisite and gracefully peaceful. Like the Humble Administrator's Garden here, located in Suzhou, it abounds in bridges, stone banks, exuberant flowers and woods. Although artificially made, the garden is brimming with natural beauty, a typical example of a private garden in this area.

◀◀ Windows with Hollowed-Out Carvings

Windows and doors are carved so that they are hollow and allow the views of another space in sight. In so doing the limited space is given unlimited changes, which is one distinctive character of private gardens. Take this window for example, it was meant to let the view outside the window leak into the room, creating an unfathomable depth of a garden within a garden.

Huizhou Houses

Huizhou houses are usually found in today's southern part of Anhui Province and northeastern part of Jiangxi Province. This type of building is in general two-storied, with tall walls encircling them and small yards inside. Huizhou houses feature black tiles, white walls, high walls shaped like horse heads (corbie-step), as well as fine brick, wood and stone craftsmanship.

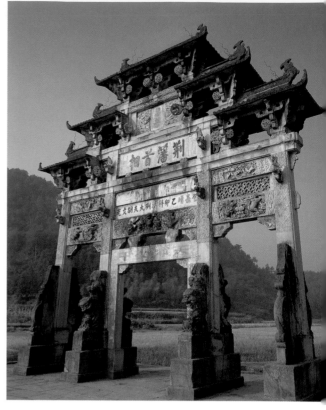

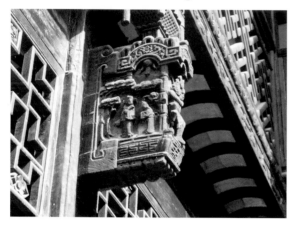

▲ Wood Carvings

Carvings of wood, brick and stone are heavily emphasized in Huizhou homes. Historical figures and folk legends are major motifs of these carvings.

▲ Memorial Arches

An architectural form unique to China. Shaped like a gateway, it was used to commemorate and celebrate deeds illustrating filial piety and righteousness. Some were erected by emperors' decrees; others were built by later generations in recognition of an individual or individuals' virtue. These memorial arches played a significant role in cementing the solidarity of a clan and attending funeral rites of relatives and loved ones.

▼ Corbie-Step

This step-like wall is called "corbie-step," which rises and falls rhythmically, adding to the depth of the space.

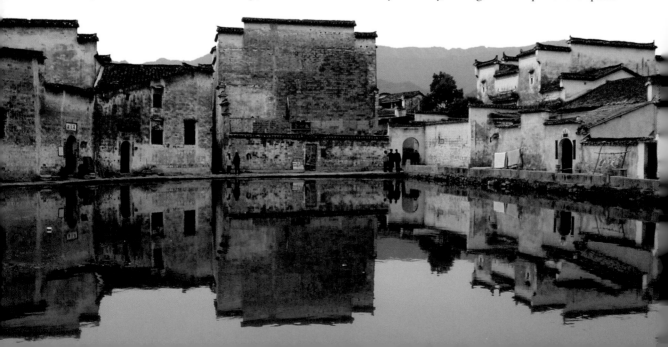

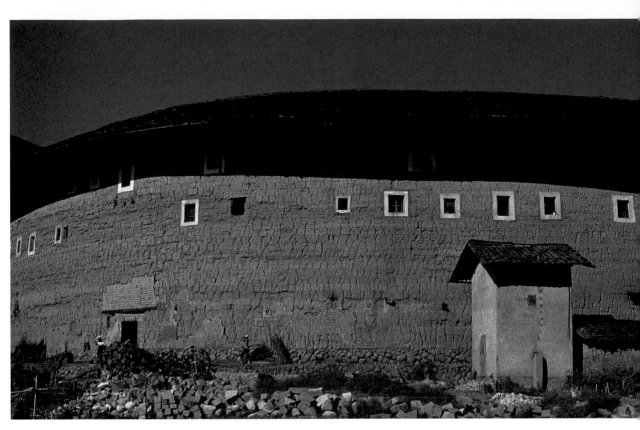

▲ **Exterior of the Earth Building**

▼ **Interior of the Earth Building**

Earth Building (*Tulou*)

Also known as the round building, it is typical of Fujian Province. Some well-kept earth building can still be found in the areas of Longyan, Shanghang in the southern part of Fujian Province. When the Hakka moved to a place and decided to settle down, they made their abode round because they wished to protect themselves from invasion and also to accommodate their custom of communal living. Encircled with a tall wall, earth building has only one stone arch exit, but it has five stories with more than 300 rooms. The first and second stories are used as storage rooms, kitchens or animal pens, and the third story and above are reserved for people to live in.

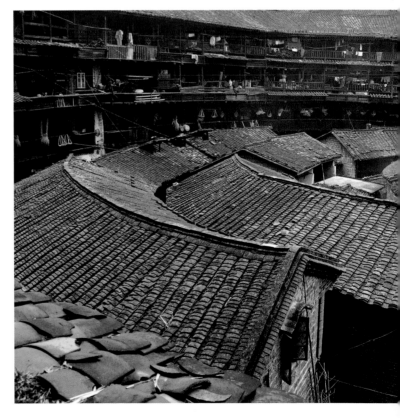

AN ASSORTMENT OF CERAMICS

Ming and Qing Dynasties

China has had a long history of porcelain making. As early as in the Eastern Han Dynasty ceramic wares were made in Changnan area (today's Jingdezhen). By the Tang Dynasty *qingci*, *baici* and *caici* emerged one after another. Among them the best-known across the world was the *sancai* (tri-color) ware that was glazed in the three colors of green, yellow and blue.

In the Song Dynasty ceramic industry flourished in China. Famous Song kilns and ceramics were found across China. A number of places became known for the ceramics they produced. The most famous were the Five Kilns: Junyao, Ruyao, Guanyao, Dingyao and Geyao. The quality of ceramic ware had reached a higher order and the variety multiplied. Consequently ceramics began to sell overseas. At that time the ceramic industry concentrated in state-run kilns, where the most skillful craftsmen gathered.

In the Yuan and Ming dynasties, *qinghuaci* (blue and white wares) produced by Jingdezhen became so well-known for its distinctive style that Jingdezhen won its good name as the capital of chinaware and grew to be the center of the ceramic industry. By the middle and late Ming Dynasty private kilns sprang up quickly. In Jingdezhen alone there were over 900 private kilns and more than 100,000 people were engaged in ceramic making.

In the Qing Dynasty the art of ceramics peaked in terms of shape, glaze, print and variety. Ceramics, synonymous with China, had become the key player in China's trade with other countries.

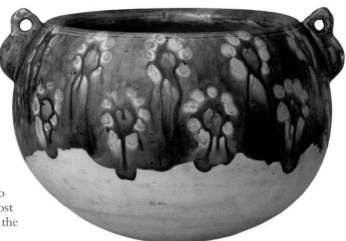

▶ **Tang Tri-Color Wares**

In the Tang Dynasty kilns were found in provinces such as Henan, Hebei, Shaanxi, Jiangxi, Zhejiang, Anhui, Fujian, Guangdong and Sichuan. The technique in ceramic firing also reached a higher level of sophistication. *Qingci*, *baici* and *caici* came into being one after another. Among them the most famous was the Tang *sancai* ware which used the colors of green, yellow and blue.

Five Famous Kilns in the Northern Song Dynasty

The Song Dynasty saw the heyday of China's ceramic industry. Ceramic wares not only sold well in domestic markets but also to other countries such as Japan, India, the Arab countries and Iran. Ceramic technique became more and more specialized and five kilns made their name in the industry.

Kiln	Location	Product Features
Dingyao	Quyang in Hebei Province	*Baici*, or white porcelain. The body clay is so fine that it has a powdery feel to the touch. Light and thin bodied, with incised design and embroidery.
Ruyao	Linru in Henan Province	Both rouge and cinnabar, clear glaze, with designs of crab claws and crackles.
Junyao	Yu County in Henan Province	Fine clay, brilliant glaze in five colors; with rabbit's hair pattern, red as blush, green like scallion, purple close to ink black.
Guanyao	Kaifeng in Henan Province	Fine clay, thin body with a hint of blue in varying shades; sky-blue is the best.
Geyao	Longquan in Zhejiang Province	Well-known for *qingci*, or celadon.

▲ **White-Glaze Brushwash, Dingyao, Five Dynasties**

▼ **Moon-White Glazed *Zun* (Wine Vessel) with Vertical Flanges, Junyao, Song Dynasty**

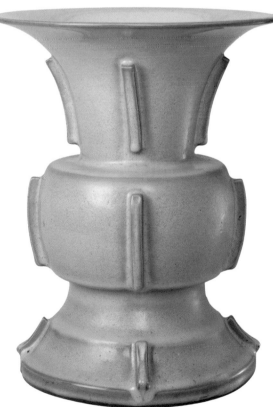

▲ **Three-Leg Blue-Glazed *Xi*, Ruyao, Song Dynasty**

▲ Flat Vase with Pierced Ears, Geyao, Song Dynasty

▲ **Blue and White Plate with Mandarin Ducks and Lotus Patterns, Yuan Dynasty**
The ceramic plate is meticulously painted. At the center of the plate are two mandarin ducks swimming among lotus flowers in a pond. Mandarin ducks always appear in pairs, and they are used to symbolize loving couples and devoted lovers in China.

Blue and White Porcelain in the Yuan and Ming Dynasties

Underglaze-decorated porcelain was popular in the Yuan and Ming dynasties. To make such wares, ground cobalt oxide was used to paint desired patterns on the body, and then the ware was covered with white glaze and fired in the kiln in 1,300℃ temperature. The finished product had blue flower patterns against the white background. They were exquisitely beautiful and were therefore called "blue and white porcelain." These wares became the mainstay of exports at the time. The most well-known were produced in Jingdezhen in Jiangxi Province. Jingdezhen thus earned its name as the capital of chinaware.

▲ **Big Vase, Guanyao, Song Dynasty**

The Heyday of China's Porcelain in the Qing Dynasty

During the reign of Emperor Qianlong China's porcelain technique culminated in terms of shape, glaze color, patterns and variety. The diversity of shapes was represented by such wares as cups, plates, bowls, etc., and accessories such as water jars, brushwash and brushpot. Moreover, exhibiting wares such as bottles, wine vessels and screens on stands. The schemes of decoration on porcelain included pictures symbolizing good luck, for example, peonies, bats and magpies. Sometimes historical and legendary characters were also portrayed.

Fencai (or Famille Rose)

Fencai is overglaze decoration for porcelain. The process of *fencai* making goes like this: pictures were painted on the body clay and then filled with desired colors; after that the ware was fired in low temperatures and the porcelain became ready. The predominant paintings were portraits of characters of Chinese legends and historical stories. Sometimes pictures of beautiful landscape, life-like birds and flowers, and symmetrical geometric patterns, were also used.

▲ *Fencai* **Vase with a Picture of a Magpie on a Peony Tree**

In Chinese folklore magpies signify a happy event and the Chinese characters 梅 (*mei*, peony) and 眉 (*mei*, brow) are homonyms. Therefore, this pattern indicates the idiom *xishang meishao*, which describes a person filled with joy (or literally, happiness jumping on your brows). The lucky symbol of "magpies on the plum," which is popular among the Chinese, is also one of the most important motifs used in porcelain decoration.

▲ **A** *Fencai* **Vase**

▼ Double-Vase Painted in Enamels Depicting "Children at Play," Qianlong Reign, Qing Dynasty

"Children at play" was one of the motifs frequently used on the Ming and Qing porcelain. Children, naive and lovely, are symbols of the continuation of life. A picture of children at play is considered lucky, and it also implies the traditional Chinese notion of more sons and more happiness.

This double-vase was a popular shape in the Qianlong period. There are two scenes of children playing—one depicts four children playing with three sheep, signifying *sanyang kaitai* (everything takes on a new look); the other portrays nine children watching bats flying from a vase. This is a visual metaphor for "more children, more bliss."

▲ Enamel Porcelain Vase with Onion-Shaped Top and Flower Patterns Painted in Gold Lines, Qianlong Reign, Qing Dynasty

Enamel painting on porcelain draws upon the technique of copper enamel painting. In the body of the porcelain, a variety of enamel paints are used to make overglazed porcelain. It is also called "porcelain body with enamel paint." *Gaizhong* means a tea cup with a cover. Many European painters worked in China's imperial palace in the Qianlong years. Chinese painters learned from them the use of perspectives in European drawing. Chinese craftsmen therefore used western enamel paint to present western themes in enamel paint porcelain. Western techniques are apparent in the flowers on this onion-head vase, and bright, gorgeous enamel paint was added, giving it a rich western flavor.

▲ **A *Doucai* Vase**

▼ Porcelain Figure of Maytreya (The Laughing Buddha)

Maytreya, or the Laughing Buddha, is one of the Buddhist statues that are worshipped and dearly loved by the Chinese people. In the Qing Dynasty the scope of porcelain production grew. In addition to cups, plates and bowls, a variety of display porcelain wares came into existence, such as this porcelain figure of Maytreya.

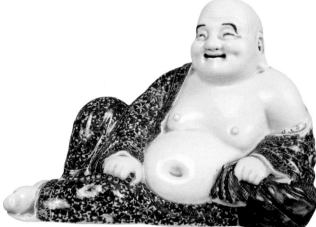

Doucai (or Contending Colors)

Doucai is made in the following procedures: paint the main part of a picture on the porcelain body and cover it with transparent glaze; fire it in a high temperature and a blue and white ware is ready; then add more colors as desired to the surface of the glazed ware and fire it another time and the *doucai* porcelain is ready.

▼ *Doucai* Vase Decorated with the Character 寿 (*shou*, Longevity)

The Chinese character 寿 (*shou*) is one of the many characters used as decorations on porcelain. The character has to be arranged in a way that is rhythmic like a flower, or be written in a way like a decorative pattern. In addition to *shou*, other character patterns include 万 (*wan*, ten thousand), 福 (*fu*, fortune) and 囍 (*xi*, double happiness) are often used.

ART FROM LIFE

Ming and Qing Dynasties

Ancient Chinese people's pursuit of fine life style and cultural elements can be traced back to the Song Dynasty, a golden period in history for the literati and officials. In the early days the Song administration put stronger emphasis on the intellectual than the military aspect of life. The literati, as a result, enjoyed the highest prestige in society. People of humble origins were able to rise to the riches by writing the Public Service Examinations and become members of the ruling class. Cultural and artistic activities prospered at an unprecedented manner.

Prior to the Song Dynasty the Chinese people used to squat, so their homes were built low. By the Song Dynasty furniture with legs such as chairs made an appearance and people switched to sitting on chairs with their feet dangling about. This change spurred people's desire for a more artistically inclined life. The pursuit of a more elegant life style became fashionable.

The Ming and Qing dynasties witnessed an unprecedented surge of social wealth, which brought about the fusion of folk arts and the high-brow arts of the literati. People became fond of elegance and refinement. The trend penetrated every aspect of life. Everything was of fine craftsmanship, be it fashion, furniture, decorations and daily utensils. They were not only practical for daily use but also work of art to be admired. They testified to people's artistic taste and the highly sophisticated handicrafts technique.

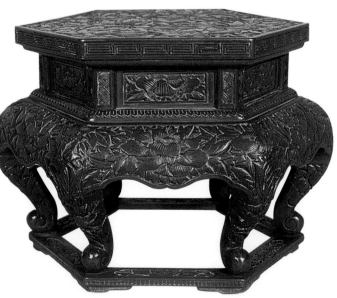

▶ **Carved Lacquer Flowerstand**
The development of classical Chinese furniture underwent a golden era during the Ming and Qing dynasties. Pieces of furniture, though made for daily use, were made of good quality material and with fine craftsmanship. Manifestations of the aesthetic achievements of ancient Chinese were found everywhere. This piece of furniture, called *huaji*, was used to hold a flower pot or a penjing (Chinese bonsai). Flowerstands usually come in pairs and are put at the corners of a hall. This stand was carved with exquisite patterns all over its surface. The peony design symbolized wealth and rank.

Rich Meanings Embedded in the Engraved Designs

Pieces of future are usually engraved with pictures or patterns bearing symbolic meanings. These patterns are so wide-spread in people's daily lives that their symbolic meanings, usually related to fortune and luck, are self-evident to the Chinese. For example, a picture with peony and phoenix conveys the wish for good fortune and prosperity; a picture of *ruyi* (literally, as you wish) and *lingzhi* (glossy ganoderma) suggests the blessing that everything turn out the way you would like it to.

▼ Ming *Huanghuali* Folding Chair with Round Back Crest Rail

The back of the chair is decorated with medallions of cloud and a stylized double dragon design. The connecting part of the curved rest to the chair is covered with metalwork ornaments decorated with the scrolling lotus design.

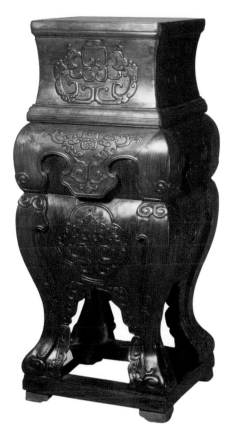

▲ Two *Chi* Holding a 寿 (*shou*) Character in Relief

Chi is a hornless dragon from ancient Chinese legends. Its head is frequently used as a motif for decoration in such places as the imperial court steps, stone tablets, ritual vessels, stamps and seals, as well as on furniture.

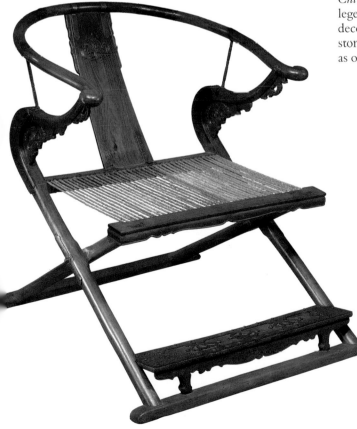

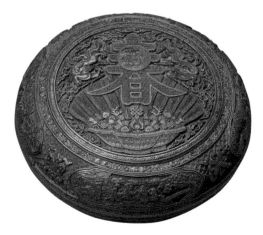

▲ *Penghe* (Food Box)

The ancient Chinese used food boxes to store food. As the techniques in making lacquerwares advanced, food boxes were more and more finely executed. Later, they were also used to store miscellaneous items.

► Copper Censer Engraved with Sea Beasts and Dragon Patterns

Copper engraving is a form of traditional Chinese sculpting art. This engraved copper censer, decorated with sea beasts and dragon patterns, has an interesting shape and demonstrates fine craftsmanship.

◄ Cloisonné Enamel Jar

In the Jingtai years of the Ming Dynasty cloisonné enamel became fashionable. What's unique about it is that it integrates ceramics with bronze or copper. First, the artist makes the body of the ware with red copper, and then inserts thin, flat copper wires to form decorative patterns on the surface of the object; after that, blue enamels such as sapphire blue and peacock blue are applied to fill in the patterns, and fire it repeatedly before finally having it polished and gilded. This finished object is called "cloisonné enamel."

► Copper Hand Heater with Engravings

This type of heater was used by the ancient Chinese to warm their hands. It was usually made of copper and had charcoal burning inside. It had a lid with many holes and a handle.

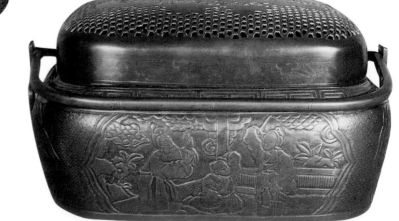

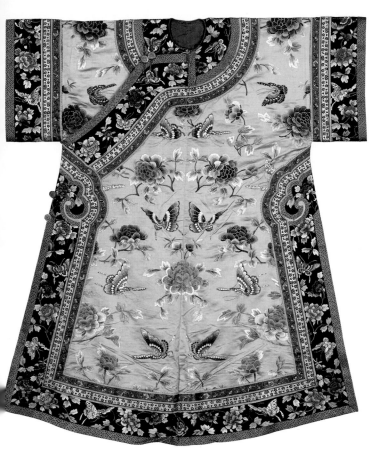

▶ Bamboo Pillow with Engravings

Bamboo engraving, also called bamboo carving, is about engraving bamboo objects with a variety of designs and words, or to carve a root of a bamboo into certain shapes for display as pieces of art work.
The art of bamboo engraving has a long history in China and peaked during the Ming and Qing dynasties.
This object, called *bige*, literally rest your arm, is used to rest one's arm in the course of writing. It prevents one's sleeves from getting stained by the ink. It is an accessory in the study.

Sailing in the Wilderness

▲ Qing Dynasty Female Costume

The colors and prints of ancient Chinese garments are richly embedded with meanings as recorded in ancient documents. By the Ming and Qing dynasties the Chinese art of weaving and embroidery had reached its peak. This garment, for instance, bright and colorful, is an example of perfect workmanship.

▼ *Ruyi*

An object considered to bring blessings and symbolize good fortune. It was popular during the Ming and Qing dynasties. Usually made of materials such as gold, silver, jade, stone, ivory, scented wood and cloisonné enamel, *ruyi* is displayed on the furniture for decoration and also signifies good fortune.

◀ Ancient Chinese Undergarment— *Dudou* (Halter Top)

Different from the Western-styled undergarment that aims at shaping one's bust, ancient Chinese undergarment emphasizes a romantic feeling. With romantic and meaningful totemic patterns, *dudou* strives to express a sense of happiness and good luck, a wish for good fortune and warding off evil spirit and disaster, and to bring about one's hopes and dreams.

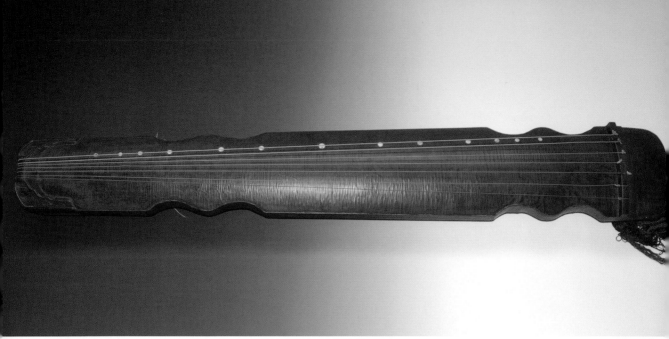

▲ *Weiping* (Folding Screen)

Weiping is a unique piece of furniture in the Chinese tradition. It was first used to shield the wind or prevent a place from being seen. The screens were usually decorated with carvings and paintings. The screen here, painted with some figures, is a folding screen, which could be one of six, eight, twelve and twenty-four panels. It opens and closes with ease. It is also removable and conveniently made for protection of privacy or for display.

◄ *Guqin*

Guqin, a seven-stringed instrument, is one of the oldest plucked musical instruments in China. It has a recorded history of more than 3,000 years. As early as the Confucius period, *qin* was a quintessential musical instrument for all literati. For thousands of years this musical instrument was an essential part of their lives. *Guqin* has a complete and independent set of playing techniques, tablature score, history and theories of composition and aesthetics, all of which constitute its musical heritage.

▶ A White Jade Screen on the Stand

This is a decorative screen to be placed inside a residence, usually by the bedside or on the table for display. On this white jade screen engraved was a well-known picture named *Hundred Birds Admiring Phoenixes*.

Engraved words are often found on the body of a *zisha* teapot. They express good wish and are also decoration to the teapot. The art of Chinese painting and calligraphy is integrated into *zisha* teapots, which adds to the cultural implication of a teapot in addition to the artistic value of decoration.

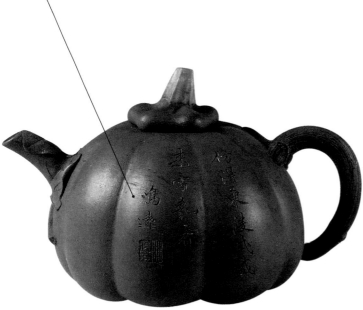

◄ *Zisha* Teapot (Boccaro Teapot)

As a time-honored custom in China, tea drinking had been particularly popular in the Ming and Qing dynasties. *Zisha* teapots first appeared in the Ming Dynasty and became all the rage in the Qing Dynasty. *Zisha*, or literally purple sand, is a unique mineral available in Yixing of China. The teapot made from this purple sand has a refined quality with smooth surface. The tea made with a *zisha* teapot retains the fragrance of the tea leaves without the interference of the smell of cooked water. *Zisha* teapots are elegant in style and pleasant to the eye. They are not only for daily use but also pieces of art. They are sought after by people with refined taste.

FOLK ARTS AND CRAFTS

Ming and Qing Dynasties

The Chinese people have a long tradition of making folk arts and crafts that are reflective of the nation's characteristics. These art and craft items not only satisfy people's utilitarian need but also provide people with artistic enjoyment. Chinese culture emphasizes auspiciousness, which is an expression of the Chinese people's wish for happiness, beauty and peace. Numerous works of arts and crafts are created to convey such good will.

Different places in China have developed different forms of arts and crafts. They include useful items such as lacquer ware, batik, embroidery and perfume pouches; items as symbols of good luck in Chinese culture, such as paper-cuts, New Year paintings, door gods and Chinese knots; and items both for fun and entertainment, such as kites, shadow play, dough modeling, clay figures and puppet show.

Materials used for making these art and craft items are usually raw. They include clay, wheat straw, bamboo, cotton thread, wood and shells of maize. The finished products are known for their ruggedness, their thickness and solidness, as well as their simplicity and clumsiness. For example, the craftsmanship of some folk carving items shows a rough-hewn feature in the employment of carving knives, while blue and white porcelain wares have simple decoration of only a few touches. A number of art and craft items also deploy the technique of exaggeration and distortion to create a comic or grotesque effect.

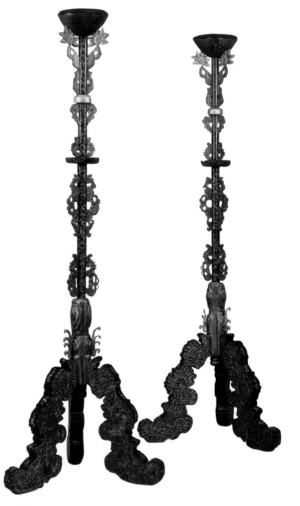

▲ Qing Carved Red Lacquered Hat Stand

The hat stand is covered with finely carved red lacquer. The round parts are smoothly shaped. The head of the stand is carved with three string moldings, dragon and entwining floral designs. The outmost part of the stand base is also carved with an entwining floral design. This hat stand can be placed on a desk since its size is small.

Lacquerware

Lacquerware has a long history. Records show that it first became available about 4,200 years ago in the Xia and Yu periods and reached a higher order in the Warring States Period. As daily utensils, lacquerware gradually became wide-spread by the Han Dynasty. The manufacturing technique was improved greatly in the Tang Dynasty. From the Song, Yuan and Ming dynasties onward the lacquerware manufacturing techniques reached as many as twenty different kinds. A way of adding an artistic touch to the object was either to have the ware painted with lacquer, or have the ware engraved and then painted, or inlay or paint pictures and patterns on the ware. Lacquerwares are generally household furniture.

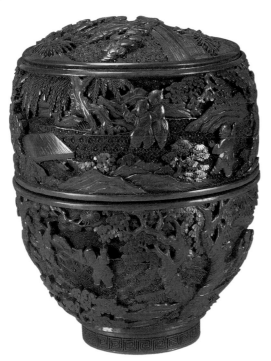

▲ **Mid-Qing Cinnabar Lacquered Box Decorated with Depictions of Playing Children**

The wooden box is decorated with a relief carving in red cinnabar lacquer. The top of the box and the surface are decorated with scenery of a courtyard, in the middle of which children are playing.

Paper-Cuts

Paper-cuts are household decorations. They are decorated throughout the house, such as the door, window, roof, and furniture including the wardrobe and cabinet. Paper-cuts are usually pictures of flowers, birds and animals in the Chinese zodiac. These paper-cuts are considered symbols of happiness, wealth, peace and harmony.

New Year Pictures

Usually put up at the New Year to decorate the house, New Year pictures, or Spring Festival pictures, are works of folk art people like to use to add to the New Year atmosphere. It is so named because it entails a blessing for the New Year. Traditional New Year paintings, usually made with woodblock printing, are mainly produced in such places as Yangliuqing in Tianjin, Taohuawu in Suzhou and Yangjiabu in Shandong Province.

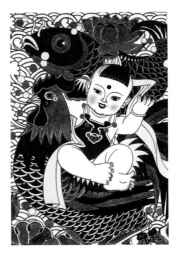

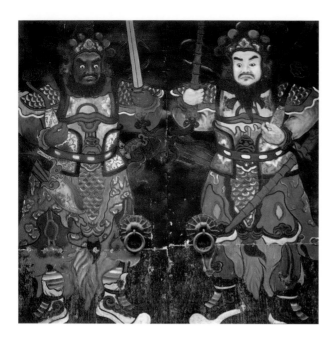

Door Gods

Door gods are paintings the Chinese people put on their doors. They are usually portraits of characters from ancient Chinese legends, such as Shen Nai, Yu Lei or the two well-known Tang generals named Qin Qiong and Yuchi Gong. Door gods are used to protect people's residence from evil spirits and convey people's good will of peace and security for the entire family.

Hand Embroidery

As one of China's most famous arts and crafts, hand embroidery has a history of more than 4,000 years. It is characterized by the neatness and subtlety of patterns, clear and bright colors, varied stitches. Embroidery is either elegant or eye-catching, an epitome of extremely fine craftsmanship. Tools needed for embroidery include a variety of embroidering frames and stands, scissors, needles and threads. Regionally, embroidery falls into the category of Su (Jiangsu Province)-style Embroidery, Yue (Guangdong

▲ Perfume Pouch
A perfume pouch is made with silk fabric. On the surface of the pouch are embroidered patterns with colorful silk yarns. The pouch can be all sizes and shapes. Stuffed inside are powders from crushed medicinal herbs that give out strong aroma. Perfume pouches are used as accessories to one's clothes. The perfume it carries also helps people stay refreshed.

Province)-style Embroidery, Xiang (Hunan Province)-style Embroidery and Lu (Shandong Province)-style Embroidery.

Batik

Batik has been an art and craft since ancient China. It has epitomized people's skills in weaving and dyeing. Batik is distinct in that the fabric has a rich assortment of print patterns in elegant, quiet colors. It has been used to make dresses, decorations and a variety of daily accessories, which are imbued with national character traits.

Chinese Knotting

Chinese knots as lucky ornaments have existed for generations. They convey a sense of warmth and reunion. Every knot is made with one full length thread. Different ways of knitting entail different meanings. To put different knots together or to attach to the knot something lucky creates a unique work of decoration, beautifully shaped and rich in meaning.

Tiger-Head Shoes and Hats

Shoes and hats made in the shape of tiger heads are not only for utilitarian purposes but also embodiment of good luck. In traditional Chinese culture tigers are considered king of all beasts and endowed with the power to ward off evil spirits. As a result, parents or elders dress their kids in tiger-head shoes and hats. This custom conveys the older generation's wish—their kids be protected and grow healthily—to adulthood.

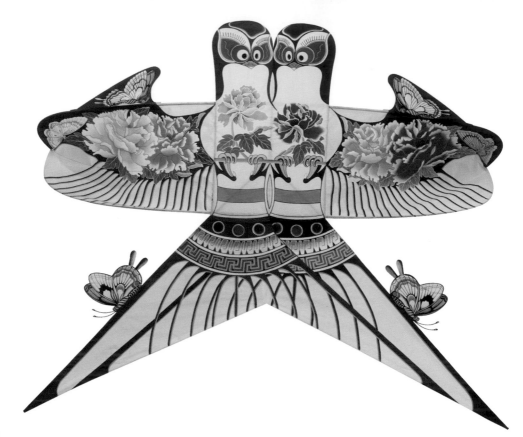

Kites

Having first appeared in the Spring and Autumn Period, kites have a history of more than two thousand years. Thanks to the development of paper making technique in the Sui and Tang dynasties, people began to make kites with paper, and flying kites gradually grew to be a popular outdoor activity. Kites are usually made in the shapes of living creatures in life, such as birds, insects, or animals that symbolize good fortune such as dragon and phoenix, or else made in geometric shapes. The building materials for kites are mainly tiffany and paper, but the keel is made of a thin bamboo strip. Weifang of Shandong Province is well-known for kites. In addition, places such as Kaifeng, Beijing, Tianjin, Nantong of Jiangsu Province and Yangjiang of Guangdong Province are also important manufacturers of kites.

Clay Figurines

Clay figurine, one of the form of China's ancient folk art. Hand-made with clay, they are primarily figures or animals, either pale-hued or bright-colored. Wuxi of Jiangsu Province has a 400-year history of clay figurine making, whose "Huishan clay figurines" are known all over the world. Huishan clay figurines employ simple sketches and exaggerated features, making them cute, plump and comic. The color schemes are usually bright with sharp contrast. Clay figurines are mainly made for children. Dough and sugar figurines differ from clay ones in materials but the techniques used are basically the same.

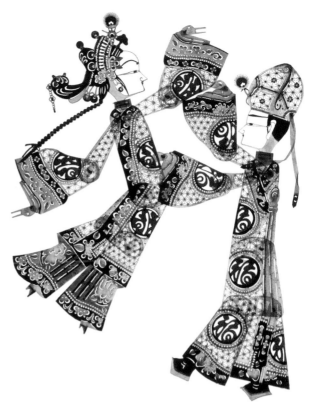

Shadow Play

Shadow play (also called shadow puppetry) dates back to two thousand years ago in the Western Han Dynasty in Shaanxi. It developed into a mature art form in the Tang and Song dynasties. The Qing Dynasty saw the heyday of shadow play.

Puppets are made of leather. Due to concerns regarding durability and the sharpness of shadow images, cowhide or donkey leather is considered the best. Colors such as red, yellow, blue, green and black are preferred for brightness. Roles of a shadow play follow the categorization of traditional Chinese operas, which include *sheng* (male), *dan* (young female), *jing* (painted face, male), and *chou* (clown, male or female).

From the Song to the Qing dynasties shadow play had been popular and well-received by the royal family and the ordinary people alike. When disseminated across the country, these shadow shows integrated with local dialects, customs and folk arts and were thus evolved into an art form rich in local characteristics.

Puppet Shows

Puppets are figurines carved out of wood. They are dolls with painted faces, decorated with hair and dressed in clothes and theatrical costumes. In ancient China they were called *yong*.

MYSTERIOUS CHINESE MEDICINE

Ming and Qing Dynasties

▲ **Tragacanth**

Chinese medicine generally refers to traditional Chinese medicine. It is a discipline that developed quite early and reached an order of maturity in ancient China. Some people tend to think that Chinese medicine is not scientific, but it is one science that has not been replaced and submerged by modern Western sciences. To this day, traditional Chinese medicine has played a critical role in the treatment of illnesses and keeping people healthy. In fact it is getting more and more attention from the world over.

Traditional Chinese medicine has a systematic body of knowledge and skills that differ completely from Western medicine. It is closely related to traditional Chinese culture. The fundamental pathology employed by traditional Chinese medicine testifies to the philosophical view of Chinese people and their view of nature. Traditional Chinese medicine originated from the Yellow River plain and has evolved over a long period of time with each dynasty making its share of contribution. Over time many doctors earned their reputation; books of critical importance were published; and important schools of traditional Chinese medicine made their appearance.

As early as the Xia, Shang and Zhou dynasties medicinal liquor and decoction were available for treatment. Oracle bone scriptures of the Shang Dynasty 3,000 years ago included records of medical and health care issues and documentation of over ten diseases.

The Zhou Dynasty saw the use of diagnostic methods such as *wang* (to observe), *wen* (to listen), *wen* (to question), and *qie* (to feel the pulse), and the means of treatment with medication, acupuncture and surgery.

During the Qin and Han dynasties, Emperor Huang wrote a book named *Classic of Internal Medicine*. The book systematically covered the theoretical foundations for Chinese medicine. The skill of a surgeon was very highly reached in the Han Dynasty and anaesthesia such as *mafeisan* was created by the famous physician Hua Tuo who used it to sensitivise the whole body during surgery.

Diagnosis by feeling the pulse made a breakthrough during the Wei, Jin, Northern and Southern Dynasties and the Sui, Tang and the Five Dynasties. Well-known physician Wang Shuhe of the Jin Dynasty (265–420) wrote a book named *The Pulse Classics* (*Mai Jing*), in which he summed up 24 different kinds of pulse diagnosis.

Li Shizhen of the Ming Dynasty spent 27 years writing a seminal work of Chinese medicine, *Compendium of Materia Medica*, which documented 1,892 different kinds of medicine and became the greatest agglomeration ever written about Chinese herbal medicine.

Theoretical Foundation and Ways of Treatment

In light of traditional Chinese philosophy, the universe is composed of two forces of yin and yang; the workings of yin and yang are the reason why the world exists. Yin and yang originally refer to the two sides to the sun: the side facing the sun is yang, while the side away from the sun is yin. As time passes, yin is interpreted as everything that is static, introvert, reclining, cold and dark, while yang is interpreted as everything that is moving, extrovert, rising, warm and bright. The interfusion and intermingling of yin and yang is considered the essence of everything in this world. The balance of yin and yang, and the harmony of yin and yang, are considered the ideal state. The reason why people get sick is, to varying degrees, the imbalance of yin and yang in the human body. The ultimate cure lies in the restoration of the balance of yin and yang.

▶ The Chinese Medicine Way

(The Qing Dynasty)

There are four ways to make a diagnosis in traditional Chinese medicine. To make a diagnosis, the practitioner is to *wang*, *wen*, *wen* and *qie*. *Wang* is to look at the complexion of the patient, his tongue, his expression and behavior; *wen* is to listen to the patient's voice and smell the patient; *wen* is to learn about such things as the patient's feeling about his physical condition, how he falls ill, his habits and medical history; and *qie* is to palpate with his fingers the patient's pulse. Sometimes the practitioner also uses his hand to feel the patient's joints, bone fractures and dislocation, clogs in the abdomen and the moisture of his skin.

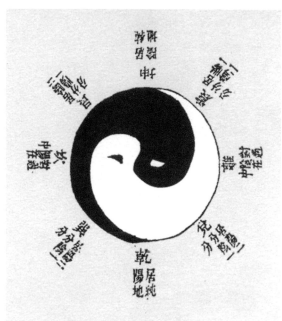

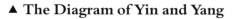

▲ **The Diagram of Yin and Yang**

▼ **The Diagram Showing the Five Agents Matching the Five Human Organs**

The theory of Five Agents is at the outset a categorization of everything in the world. Traditional Chinese philosophy holds that everything in this world can be classified into five properties of Wood, Fire, Earth, Metal and Water, which correspond to the five tastes: hot, sweet, sour, bitter and salty; and to the five colors: blue, yellow, red, white and black; and to the internal organs in a human body: heart, liver, spleen, lungs and kidneys, and even to the five human emotions: worry, longing, happiness, anger and fear. Within these five categories they are interrelated, sometimes complementary to each other, sometimes exclusive of each other. Such ideological framework has been a guiding post for practitioners of Chinese medicine to understand the relations of human organs and determine corresponding treatment.

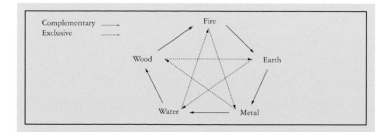

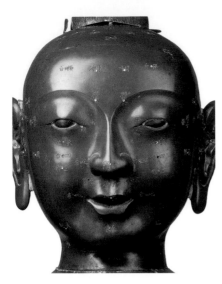

▲ **Acupuncture**

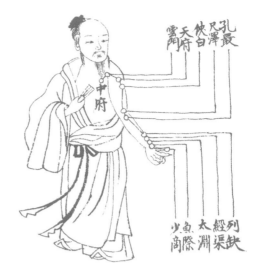

▲ **The Diagram of Channels and Collaterals of a Human Body**

The theory of channels and collaterals of Chinese medicine has been mysterious to many people. It is unlikely for modern science to lay hand on the "channels and collaterals" to which Chinese medicine holds so strongly. According to theories of Chinese medicine, channels and collaterals run throughout the human body and facilitate the circulation of *qi* (breath, life force, or spiritual energy) and blood. They crisscross inside the human body constituting an organic system similar to that of water systems in nature.

▲ **Moxibustion**

In addition to oral prescriptions, most of the external treatments are based on the theory of channels and collaterals. For instance, acupuncture, moxibustion and cupping are all the means the Chinese medicine employs to facilitate the smooth circulation of the channels and collaterals so that the body can regain its harmony.

▶ **A Page from *Classic of Internal Medicine by Emperor Huang***

Classic of Internal Medicine by Emperor Huang is the earliest seminal classic of Chinese medicine. It has been passed on generation after generation to this day. The book consists of two parts: *Suwen* and *Lingshu*, with eighty-one chapters in nine volumes. In terms of the content, *Suwen* focuses more on the physiological and pathological knowledge of the ways of yin and yang, how to stay healthy throughout the four seasons, as well as knowledge of the internal organs and channels and collaterals, while *Lingshu* primarily deals with treatments by way of acupuncture and moxibustion.

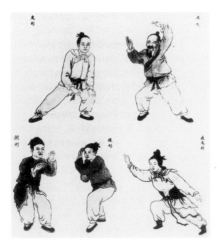

◀ **Five-Animal Mimic Boxing**

The five-animal mimic boxing is an exercise by imitating the movements of five animals (tiger, deer, bear, chimpanzee and bird). It hints at the idea of the Five Agents. Created by Hua Tuo, a famous doctor of the Three Kingdoms Period, the five-aminal mimic boxing has been used to promote healthy living by exercising one's body. Hua Tuo also invented a numbing powder called *mafeisan* as anesthesia for surgical operations.

▲ Compendium of Materia Medica

In voluminous fifty-two volumes, *Compendium of Materia Medica*, written by Li Shizhen, the Ming physician and pharmacologist, is a master piece of highest acclaim regarding *materia medica* in ancient times. The book has systematically listed 1,892 drugs that are organized under sixteen sections and sixty categories. Also included are 1,109 illustrations and over 10,000 prescriptions.

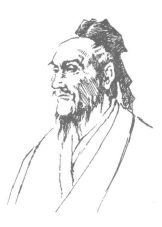

▶ Portrait of Zhang Zhongjing (150–219)

Living in the second half of the Eastern Han Dynasty, Zhang Zhongjing, known as the "Sage in Medicine," was one of the eminent figures in the development of Chinese medicine's internal medicine. The book he wrote, *Treatise on Febrile and Miscellaneous Diseases* (*Shanghan Zabing Lun*), is the first classic work on medicine that encompasses pharmacology, prescriptions and pharmaceutics. In his book he established the six stage differentiation, a doctrine that divides symptoms developed in the duration of a disease caused by external factors, and he also offered corresponding principles for treatment.

Tools and Instruments in Chinese Medicine

A whole set of tools and instruments were developed as Chinese medicine evolved. Given the characteristics of Chinese medicine, these implements were designed to meet such needs as storing medicine, processing medical herbs, as well as instruments for diagnoses and treatments. They include medicine drawers, pots, rollers, needles and pillows, to name just a few.

▶ A Roller

This is for grinding medicinal herbs.

▼ A Pot

This is for decocting medicinal herbs.

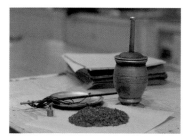

▲ Jars

This is for storing ready-made medicine.

▲ A Mortar

It's for crushing medicinal herbs.

▶ A Traditional Medicine Cabinet

Medicinal materials are arranged in a meticulous way.

▲ A Pillow

This is for resting the patient's arm while the doctor is feeling his pulse.

Chinese Medicine

Traditional Chinese medicine employs a variety of materials as medication, such as animal body parts, plants and minerals, but plants account for the great majority. *Materia medica* of Chinese medicine was in fact the pharmacology in ancient China. It recorded the name of the medicine, its special characteristics in terms of its nature, its function, what it could cure and where it could be found, as well as how to pick and process medicine.

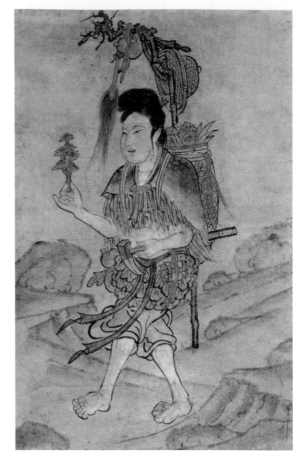

▲ **Picking the Herbs**

▲ **Aweto**

▲ **Chinese Wolfberry**

▲ **Chrysanthemum**

▲ **Lotus Seed**

▼ **Sea Horses**

◄ **Glossy Ganoderma**

▶ **Ginseng**